OIL &
ACRYLIC
WORKSHOP

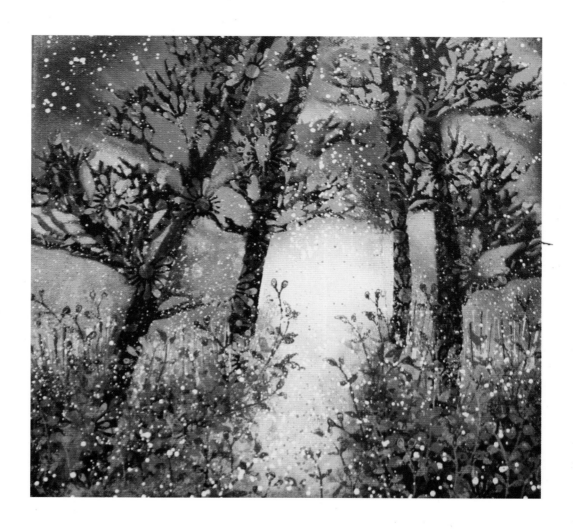

Walter Foster

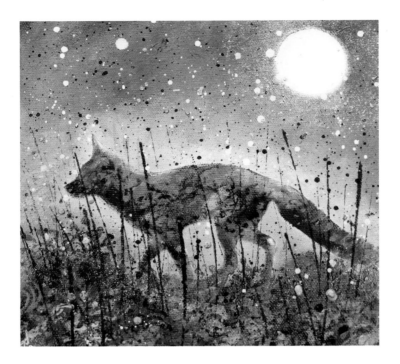

Quarto is the authority on a wide range of topics.
Quarto educates, entertains, and enriches the lives of our readers—
enthusiasts and lovers of hands-on living.
www.quartoknows.com

Artwork on cover and pages 98-127 © Yiqi Li
Artwork and photos on pages 4-51 © Kimberly Adams
Artwork and photos on pages 1, 52-97, and 128 © Bridget Skanski-Such
Photos on pages 100-101 © Shutterstock

Project Editor: Nicole Sipe
Page Layout: Jacqui Caulton

6 Orchard Road, Suite 100
Lake Forest, CA 92630
quartoknows.com

Visit our blogs at quartoknows.com

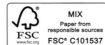

MIX
Paper from
responsible sources
FSC® C101537

Printed in China
1 3 5 7 9 10 8 6 4 2

Contents

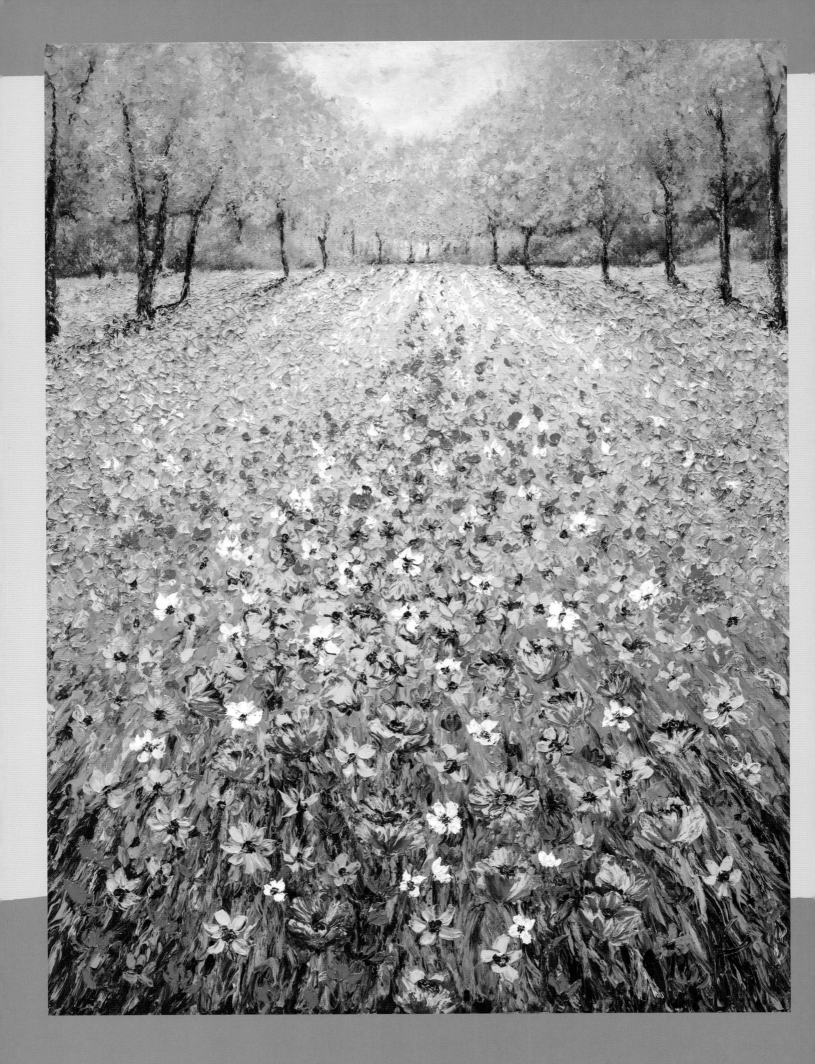

Introduction

Oil and acrylic are two of the most popular and versatile painting mediums available today. No matter your skill level, if you've ever painted before, you probably used paintbrushes and acrylic or oil paints to create art.

Now it's time to branch out and try something new with the help of *Oil & Acrylic Workshop*! This book features tips, techniques, and art from three diverse oil and acrylic artists. Learn about their tools and materials as well as their distinctive methods, and then create your own expressive, vibrant, and unique art using the step-by-step projects featured in this book.

First you'll meet Kimberly Adams, who uses her fingertips and oil paints to create gorgeous landscapes full of texture and detail. Then Bridget Skanski-Such reveals the varied tools and techniques, including acrylic paints, brushing, stippling, block printing, spattering, and finger painting, that can be used to create her romantic, magical animal and nature subjects. We finish with Yiqi Li, who uses palette knives and oil and acrylic paints to convey the emotion and beauty in nature.

Learn how these three artists' tools and materials work, and then express yourself via the diverse methods and endless colors, textures, and effects featured in *Oil & Acrylic Workshop*. Let's get started!

kimberly adams

CONTEMPORARY IMPRESSIONIST KIMBERLY ADAMS creates vibrant landscapes without brushes or tools, applying the paint only with her fingertips. Kimberly studied art at a young age and took private lessons in the small town where she was raised in New Mexico. She pursued her passion for art by studying fine art in college, where her emphasis was on pastels and human figure drawing. She is now considered a finger painter of fine art.

Kimberly lives in Washington and is an active member of the board of directors for Parklane Fine Art Gallery in Kirkland, Wash. She is deeply rooted in the art community in Kirkland and teaches workshops at Cole Gallery in Edmonds, WA. Her paintings represent her love for nature and her adventurous heart.

View more of Kimberly's work at www.artbykimberlyadams.com.

tools & materials

Paint

When finger painting with oil, choose an oil paint with lots of pigmentation. You will see better results when blending and building texture with high-quality paint. This is especially true with finger painting because the paint colors are mixed directly on the canvas, straight from the tube, and not on a palette first. Oil paints with less pigmentation tend to contain more filler, and they can become sticky or oily.

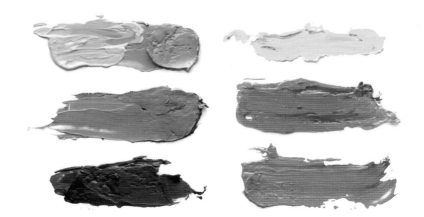

CANVAS

You will need a primed cotton or linen canvas. Gallery-wrapped canvases work well with finger painting because you can hang the painting without framing. The canvas can be finished by painting a solid color on the edges, or you can continue the painting on the sides.

GLOVES

Medical-grade gloves can be found at your local pharmacy or ordered online. It's important to find a size that fits your hands snugly, but not so tight that they're uncomfortable. Loose-fitting gloves make it difficult to control the paint when applying it to the canvas. Ensure that the gloves are of good quality to avoid breaking through the fingertips. Gloves should last over several weeks. Gloves also make cleanup fairly easy—all you have to do is remove them when you are done.

PAPER TOWELS

To maintain vibrant colors, paper towels are necessary to clean off your fingertips between color applications. Keep plenty nearby, as you will use quite a few throughout the process.

EASEL OR TABLE

An easel is helpful when finger painting because it holds the canvas in place when you are applying the paint. Placing the canvas on a flat surface works well too. You can also use a table easel as long as it is secure and stays in place while painting.

Safety is essential when finger painting.

techniques

YOU CAN ACHIEVE AN ENDLESS NUMBER of finger-painting techniques by varying the size of the stroke, the amount of paint, and the pressure that you apply to the canvas. Here are just a few examples of texture and detail that you can create. I encourage you to try a variety of techniques to discover your own unique effects.

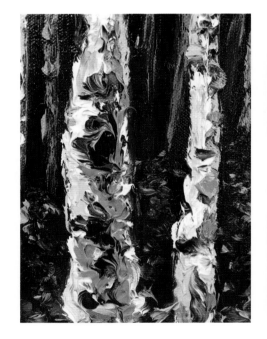

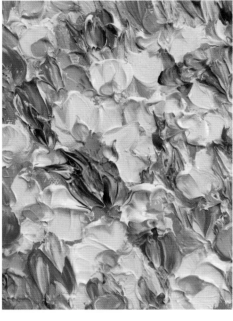

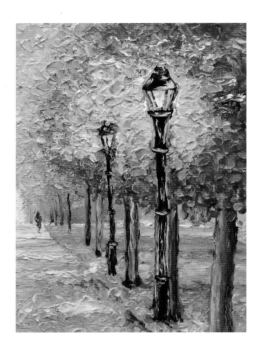

LAYERS OF COLOR

Use multiple layers of color to achieve a three-dimensional effect.

SMALL STROKES

Create different shapes by using smaller paint strokes.

LINE DETAILS

Produce subtle line motion by applying very light pressure.

Finger painting on a small canvas, such as 16" × 20", is ideal for beginners. As you become more comfortable with the process, you can work up to larger canvases. I wouldn't go smaller than a canvas that is 11" × 14", as you'll see better results when you have room to play.

Swirls

Mixing colors by swirling can create the appearance of movement.

Large Strokes

Achieve bold effects with larger strokes in a variety of shapes.

Dabs of Paint

Large dabs of paint add depth as a finishing touch.

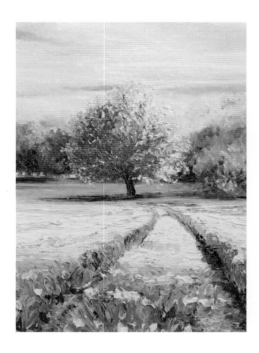

Tapping

Tapping your finger into other colors with a little paint can create a soft, faded look.

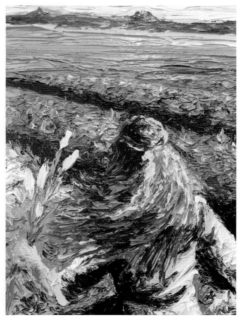

Point Details

Use the point, or peak, of a kiss-shaped dab of paint to add details.

When working with thick textures of oil paint, it's important to work when the layers are still wet. Once you start painting, you typically have 24 to 30 hours before the paint starts to set.

golden fields

FALL IS ONE OF MY FAVORITE TIMES OF THE YEAR. In this landscape, I wanted to capture a field just as the leaves and meadow started to change color. I made the hero of this painting the meadow with the magnificent yellows illuminated against the green grass. Because this painting is created in an impressionistic style, I can play with the unlimited possibilities of where my imagination can take me in the subtle fall setting.

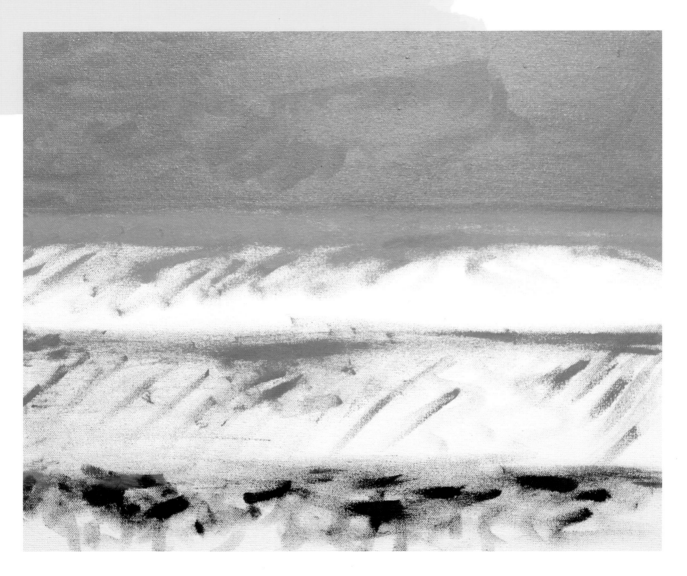

step 1

I start with a fresh, primed canvas and apply a light coat of horizon blue to the top third of the canvas, spreading the paint to keep it smooth.

Now I block in the meadow colors. To achieve dimension and depth, I fade from the lightest color (yellow-green), gradually go darker (cadmium green), and finish with a light, sporadic coat of phthalo green toward the bottom. Notice that as the colors become darker, I use less paint and allow more of the white canvas to show through. This will show me where I need to add depth.

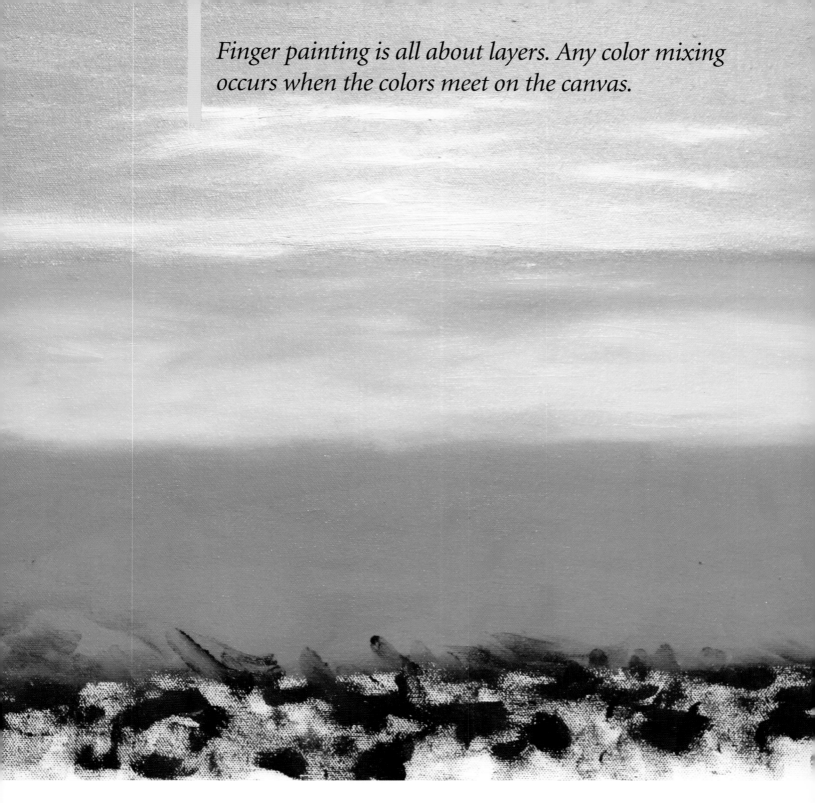

Finger painting is all about layers. Any color mixing occurs when the colors meet on the canvas.

step 2

I add the second layer using more pressure. In the yellow-green section, I add lemon-yellow, and in the cadmium-green section, I add yellow-green. Toward the bottom, I use dry fingertips to mix the phthalo green into the cadmium green. Remove any harsh lines, and keep the edges very soft.

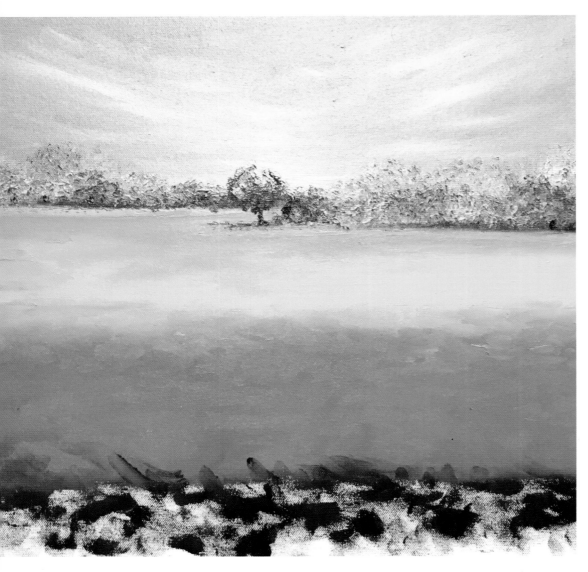

step 3

In the top section, I add misty blue, starting in the middle and fading it toward the corners of the canvas, almost in a "V" pattern. At the horizon line, I add a thin line of mauve from left to right, ending just past the center of the canvas. About an inch down on the right side of the canvas, I add another thin line of mauve.

To create colorful trees, I use light amounts of jaune brilliant, yellow ochre, cadmium yellow, yellow-green, lavender, and lilac. Starting at the line of mauve, I pick one of the colors and move in circular motions from left to right. Then I wipe off my gloves, pick another color, and start again. I continue until all the areas between the horizon line have been filled in.

I purposely place the paint at different heights to give the appearance of different shapes and colors in the distance. To build perspective, I paint taller trees on the sides and smaller trees toward the middle.

step 4

Just under the base of the trees, I add ice blue. I work gently as I move my fingers across the canvas. Placing a light color next to a dark color creates a focal point and a burst of color.

 Just below the focal point, I add lemon-yellow and gradually move toward the bottom of the canvas. I place paint roughly the size of a pea on my index finger and use that to build texture. Toward the horizon line, I use my finger to make small lines close together. As I move farther down the bottom of the canvas, the paint gets more sporadic.

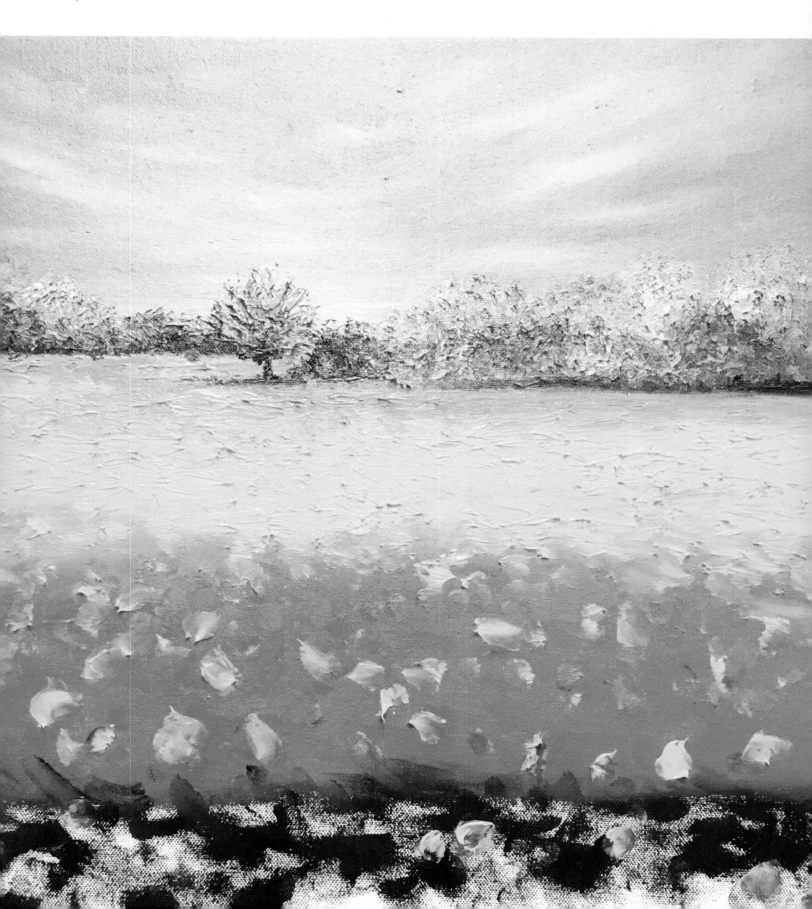

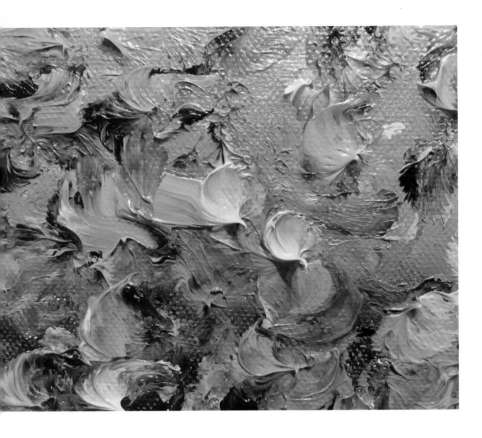

step 5

With yellow-green paint, I add texture in between the lemon-yellow. I apply thick paint and let it swirl and pick up other colors as I add it to the canvas. Toward the bottom, I use cadmium green, and then add a little ice green to give depth where the canvas peeks through.

Clean your fingers before adding more paint to keep the colors vibrant.

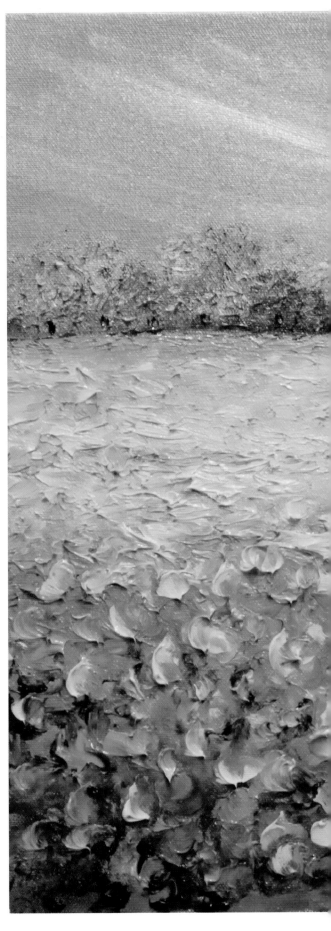

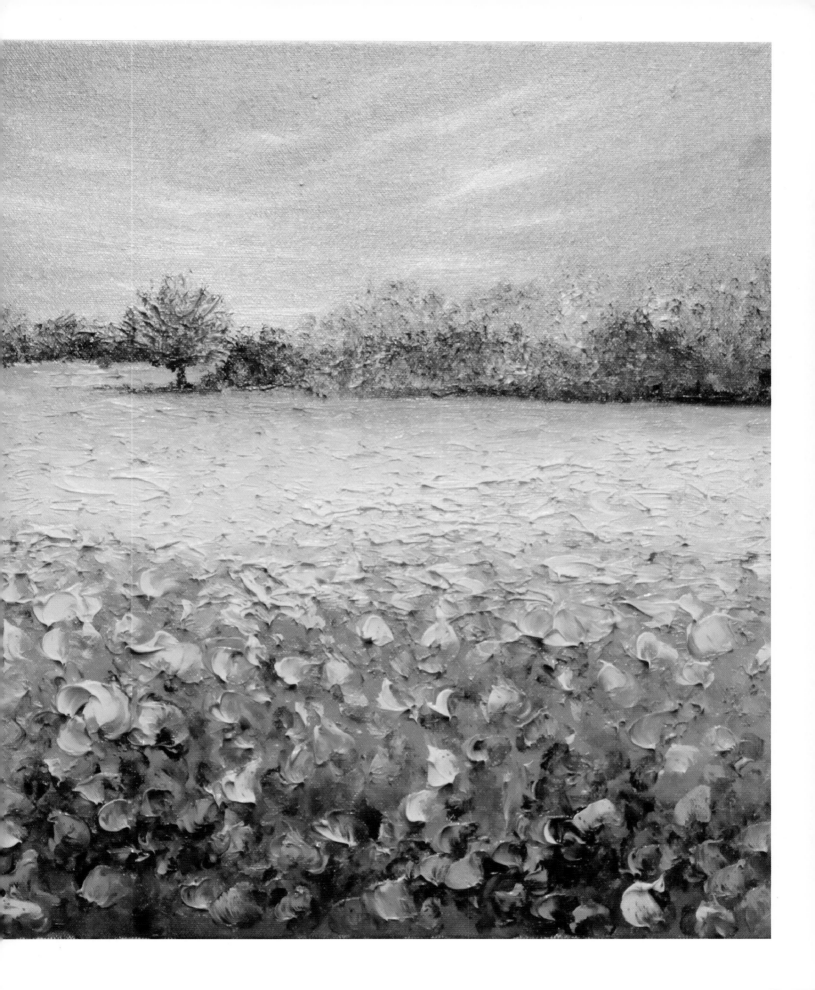

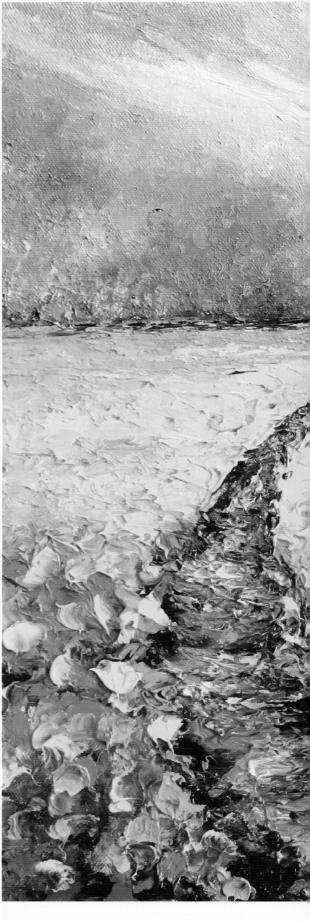

step 6

With dry gloves, I sketch where I want to place a path. Then I remove the paint in the area of the path with a palette knife or the back of a tube of paint.

Place a thin line of mauve on both sides of the path. I use imidazolone brown where I want shadows, and yellow ochre for the rest. I touch up the shadows with lavender and the light areas of the path with Naples yellow and misty blue.

I apply imidazolone brown where I want the fence. I add yellow ochre over the imidazolone brown and then a touch of Naples yellow for highlights.

For the finishing touch, I fade the trees into the background. I take a tiny amount of lilac and lavender and work over the paint that I applied earlier. Using a circular motion, I blend and soften the edges. Leave one tree brighter than the rest to add depth.

When painting with texture, it works best to paint the entire background first, and then place objects or subjects in the foreground.

after the rain

WHEN I PAINT LANDSCAPES, I like to determine a focal point that supports the story I'm telling. The star of this spring landscape is the sky and the dramatic clouds. More than half of the canvas is devoted to the sky, and I purposely use the darkest and lightest areas to help draw the eye to the focal point.

step 1

Starting with a primed canvas, I paint the top two-thirds with a thin layer of horizon blue. I intentionally leave white areas of the canvas showing through.

Now I add phthalo blue for contrast and depth. I apply the paint to the top corners, blending toward the center of the canvas in a V-like motion. As I gradually move to the bottom of the canvas, I begin to straighten my strokes and paint horizontally.

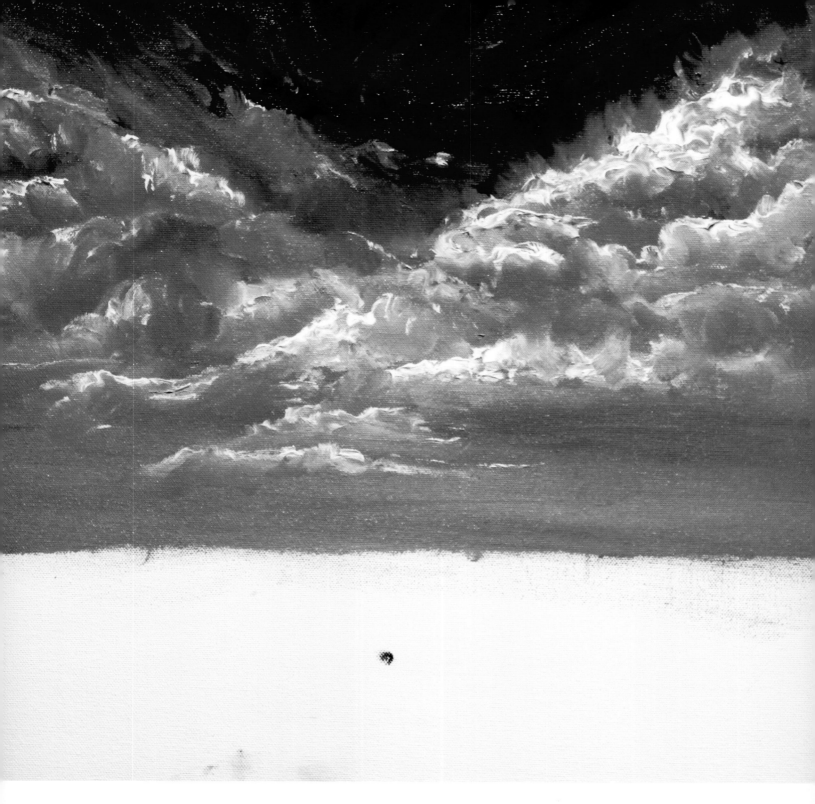

step 2

To paint the clouds, I add small, thin, wavy lines of titanium white. Starting from the right corner, I place the paint at an angle toward the center of the canvas, and then do the same on the left side. These lines are random. The goal is to avoid creating patterns. With the edge of my thumb, I blend with a downward half-circle motion. I try not to create any straight lines. Between blending, I dry my gloves.

I repeat the same effect on the left side, starting from the top left and moving toward the center. I continually step back and look at the shapes of the clouds. I add the brightest white where the light would hit them; where the light would fade, I soften the edges and blend the white so it almost disappears.

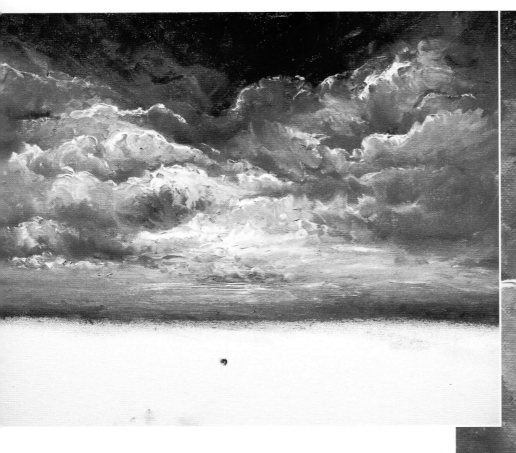

step 3

I add a small amount of phthalo blue where I want more depth, separation, dimension, and movement. I add my darkest blue next to my lightest white where I want to draw attention.

step 4

Now I'm ready to block in the shape of the meadow. I begin by adding yellow-green at the horizon line and continue to paint down the middle of the canvas. I purposely leave an area where I will add a path later.

I add phthalo green to the bottom corners of the canvas and paint upward to overlap the yellow-green.

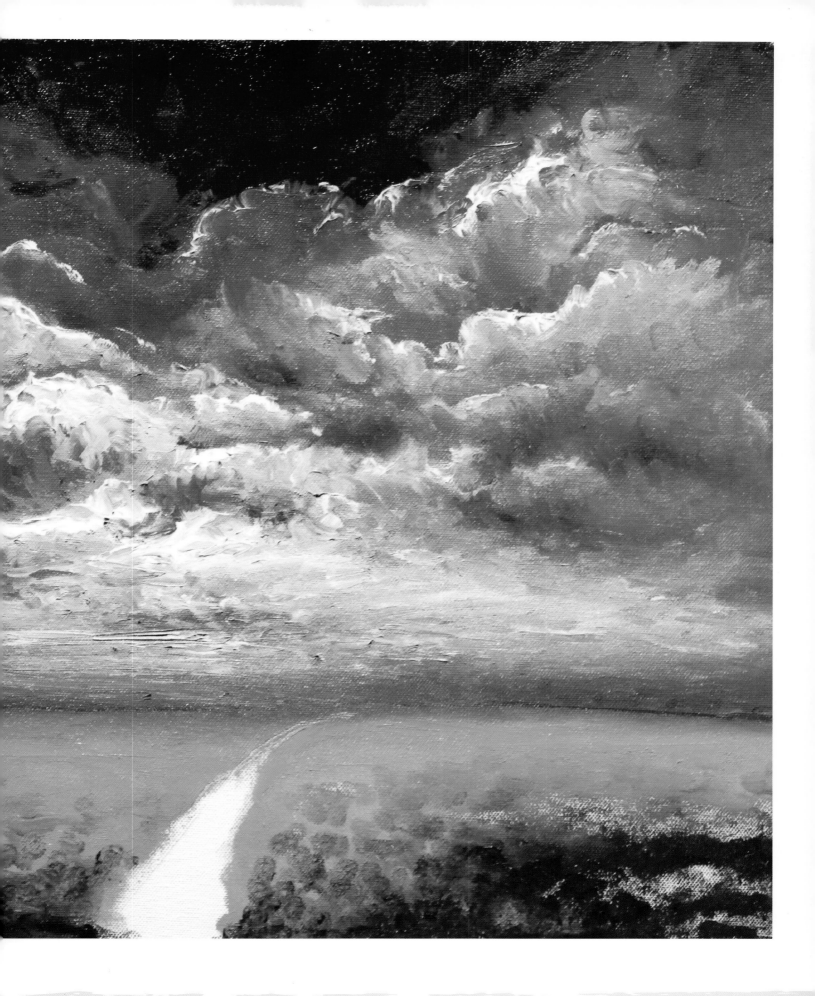

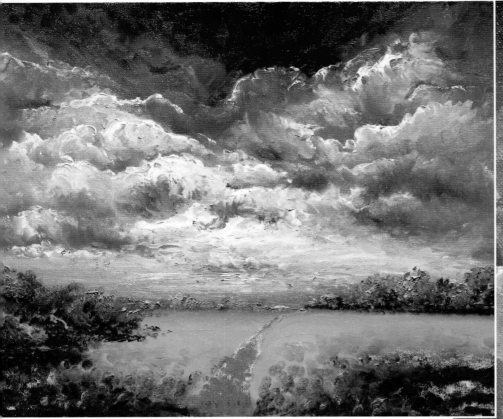

step 5

Now it's time to add some color. I use phthalo green and lavender to create trees in the distance and a few bushes in the foreground. I blend and lighten the trees to the right to help them fade away. I make the bushes in the foreground larger to give the illusion that they are closer. I add yellow ochre to the path.

step 6

I add horizon blue to the darkest areas of phthalo green. I add lemon-yellow to the bushes and trees and a touch of jaune brilliant where my light source would hit them, and then shade with lavender and lilac.

I use jaune brilliant and Naples yellow to warm up the pathway and a hint of ice green and lilac to cool the warmer colors. I add mauve to the edges of the pathway, blending it to create a shadow. I add misty blue and Naples yellow in the areas where light would hit the path. I also add titanium white along the path to tie in with the white in the clouds. Once complete, my pathway disappears into the distance and the clouds roll in for a dramatic effect.

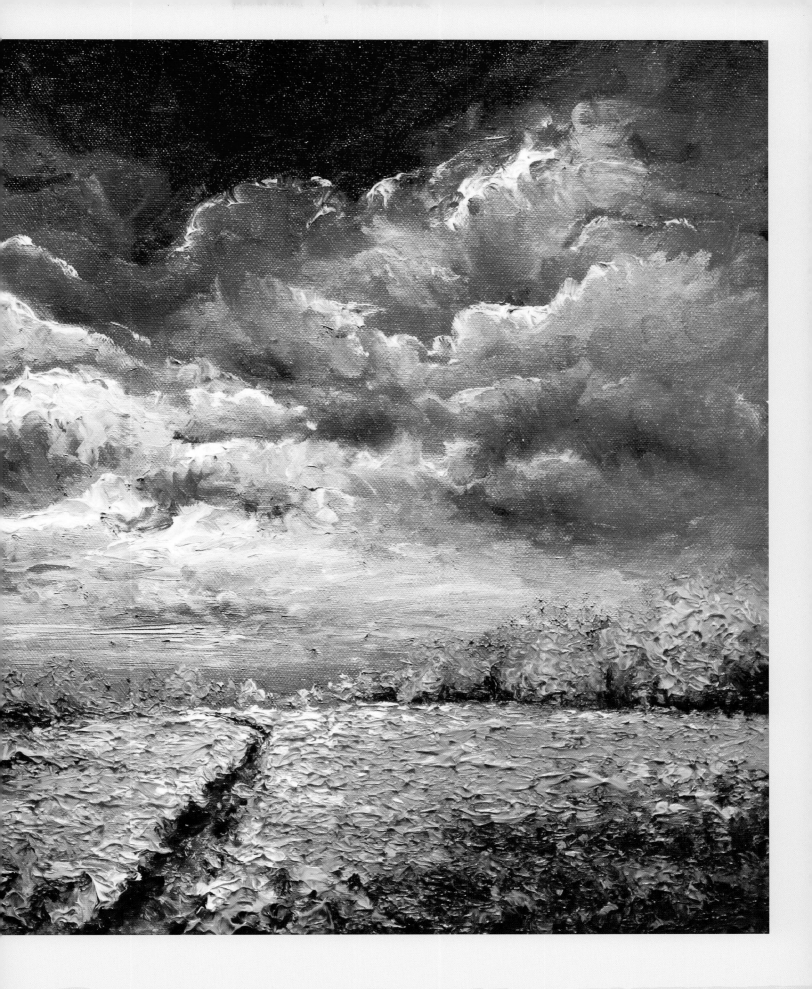

restful

NATURE IS FASCINATING. When we wander onto a trail, it can seem like it goes on forever. In this vertical landscape, a feeling of depth is captured on the canvas, resulting in a cool and restful landscape.

step 1

I use a pencil to sketch out a horizon line just above the bottom third of the canvas. I add several angles leading toward the center for a focal point. Then I sketch out a pathway and the edge of my tree line on the right as well as a meadow and bushes on the left. I add a thin layer of horizon blue to the top right, descending down in an angle toward the horizon line, and leave areas of the canvas showing through.

step 2

Painting in vertical stokes from the top of the canvas toward the horizon line, I fill in the white areas of the canvas with a thin layer of ice green.

step 3

With yellow-green, I add small dabs of paint to the sides. I also add subtle touches of yellow-green to shape the meadow and create foliage.

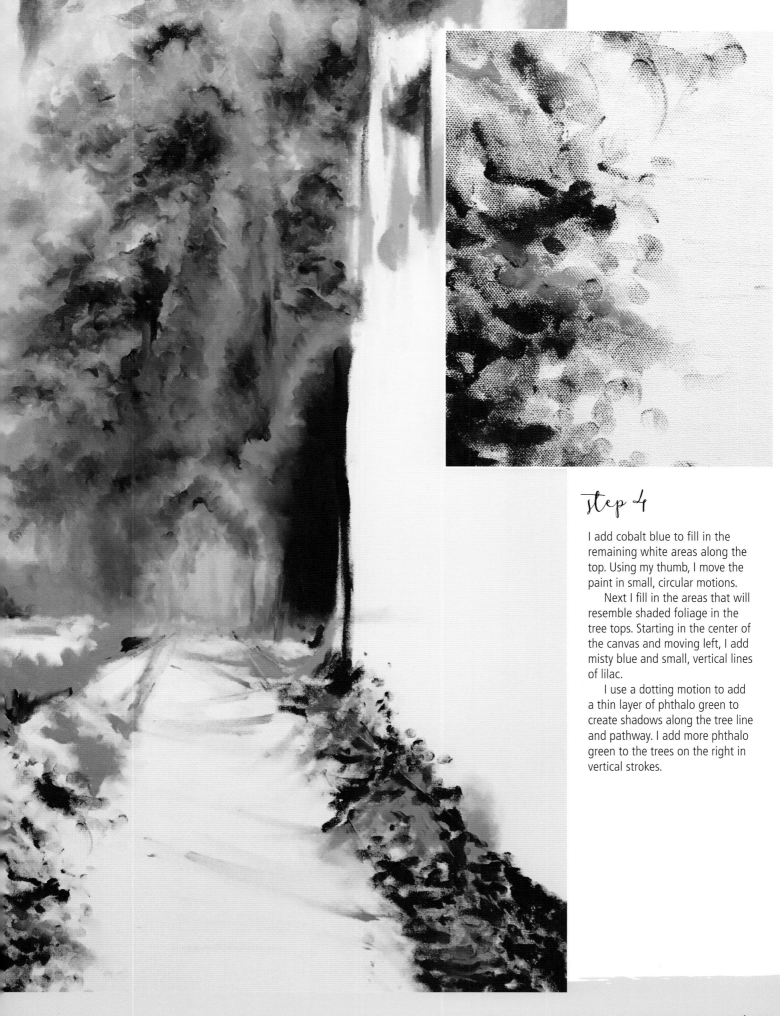

step 4

I add cobalt blue to fill in the remaining white areas along the top. Using my thumb, I move the paint in small, circular motions.

Next I fill in the areas that will resemble shaded foliage in the tree tops. Starting in the center of the canvas and moving left, I add misty blue and small, vertical lines of lilac.

I use a dotting motion to add a thin layer of phthalo green to create shadows along the tree line and pathway. I add more phthalo green to the trees on the right in vertical strokes.

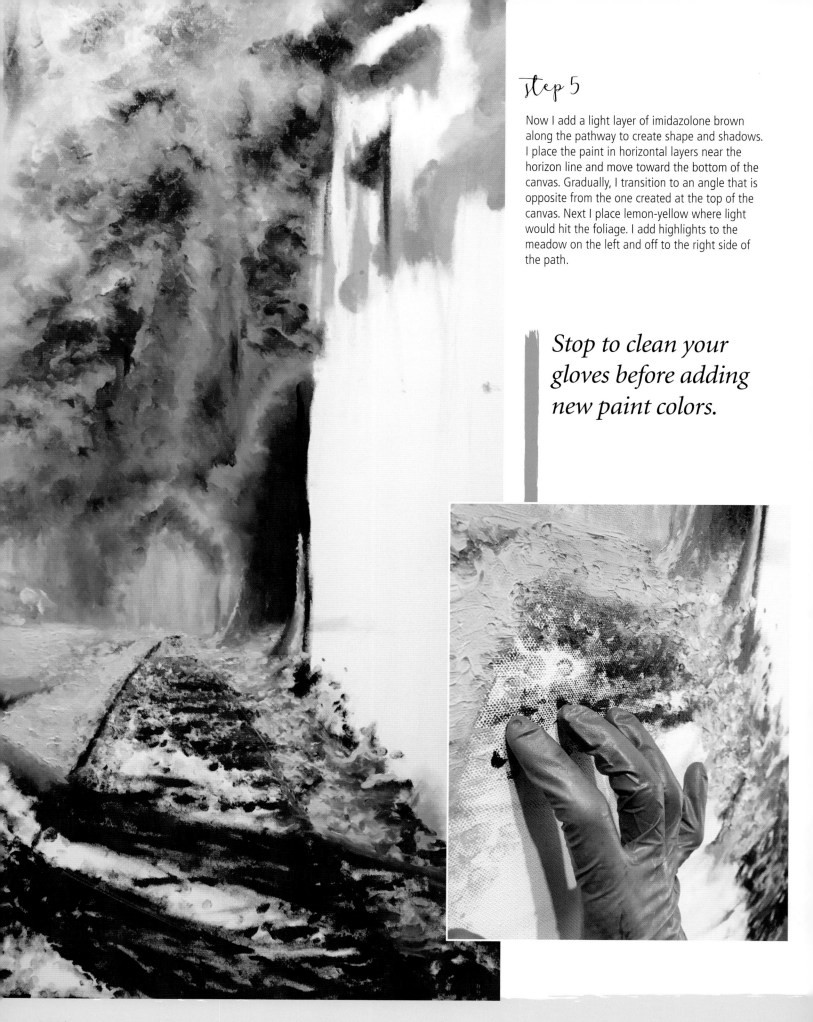

step 5

Now I add a light layer of imidazolone brown along the pathway to create shape and shadows. I place the paint in horizontal layers near the horizon line and move toward the bottom of the canvas. Gradually, I transition to an angle that is opposite from the one created at the top of the canvas. Next I place lemon-yellow where light would hit the foliage. I add highlights to the meadow on the left and off to the right side of the path.

Stop to clean your gloves before adding new paint colors.

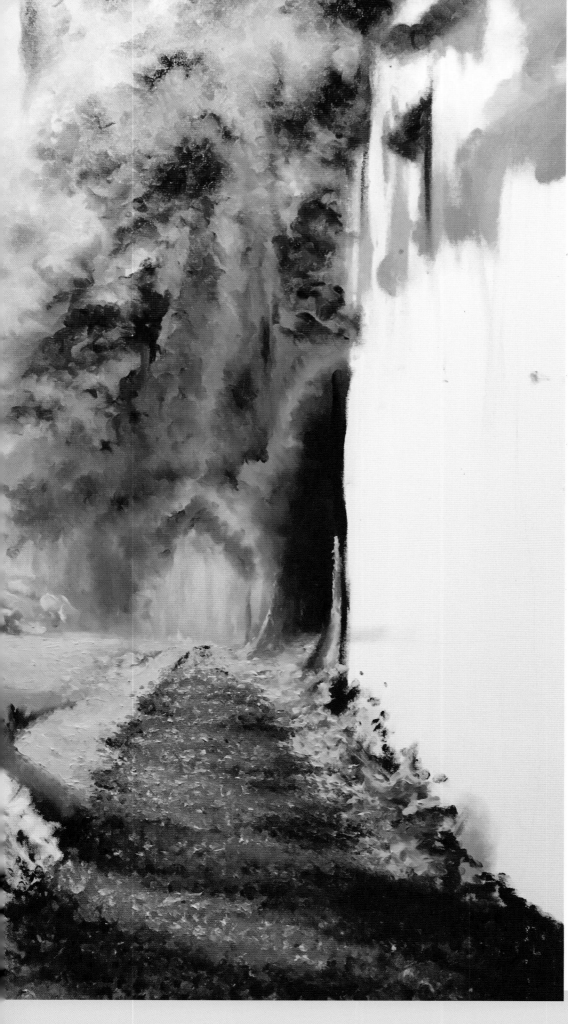

I fill in my pathway with a thin layer of yellow ochre, allowing the color to blend with the imidazolone brown. I allow the phthalo green to bleed into the paint I used on the pathway to add a realistic feel.

Next I add highlights and reflections of light on the pathway. Beginning at the horizon line and moving toward the bottom of the canvas, I add sporadic dots of misty blue. The closer I get to the bottom, the larger I make the dabs of paint and the more space I leave between them. I repeat with lilac and then yellow cadmium.

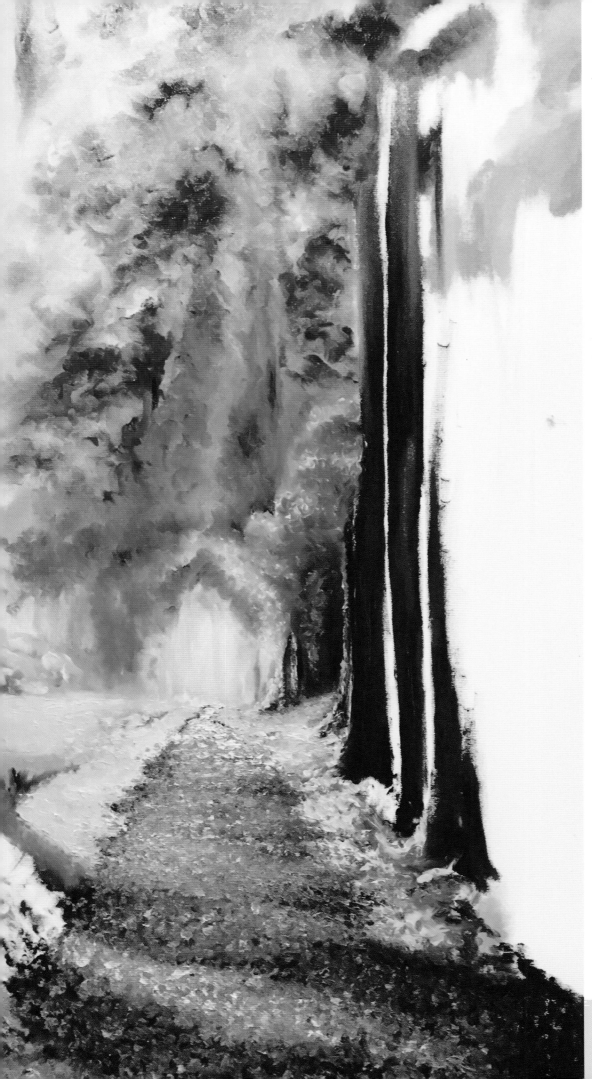

To add depth to the painting, I create more shadows on the pathway with mauve and imidazolone brown, and then I add lavender to the darkest areas of the path. I start shaping the first layer of trees on the right foreground and the trees in the background with imidazolone brown.

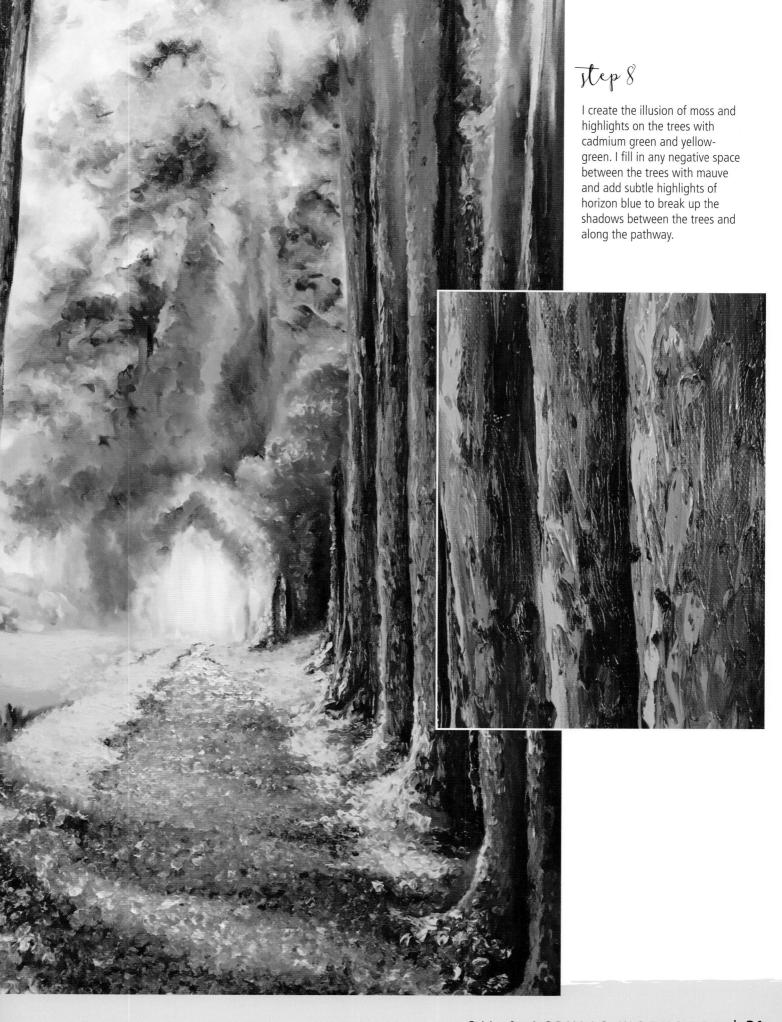

step 8

I create the illusion of moss and highlights on the trees with cadmium green and yellow-green. I fill in any negative space between the trees with mauve and add subtle highlights of horizon blue to break up the shadows between the trees and along the pathway.

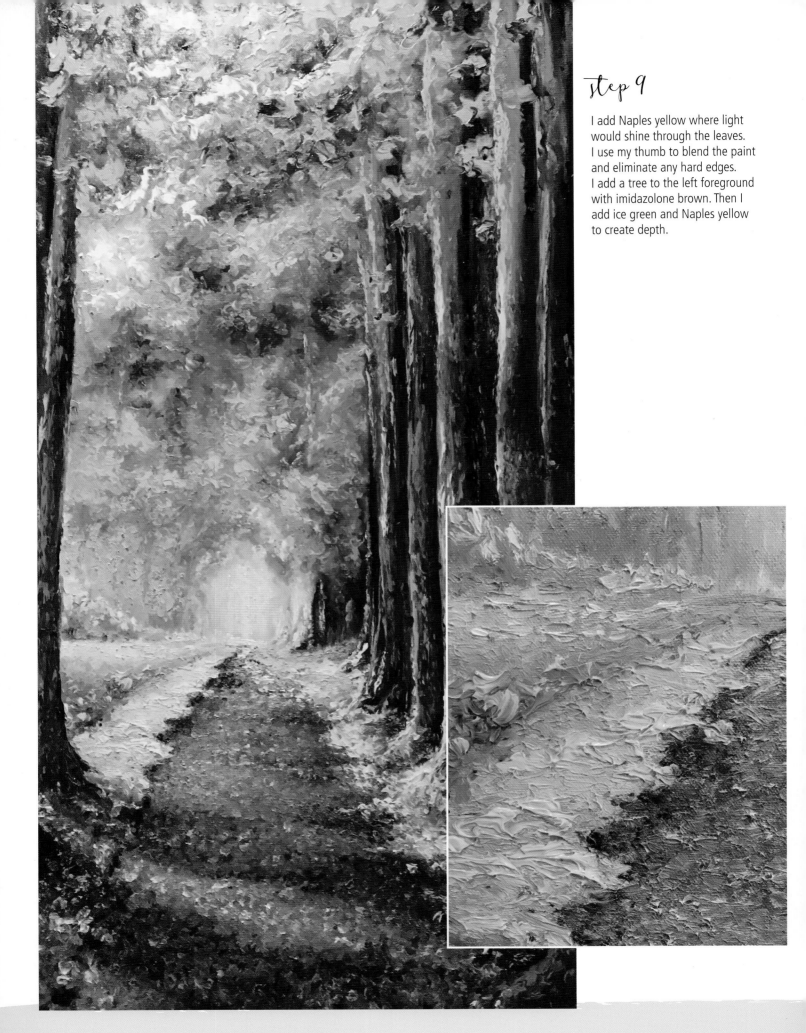

I add Naples yellow where light would shine through the leaves. I use my thumb to blend the paint and eliminate any hard edges. I add a tree to the left foreground with imidazolone brown. Then I add ice green and Naples yellow to create depth.

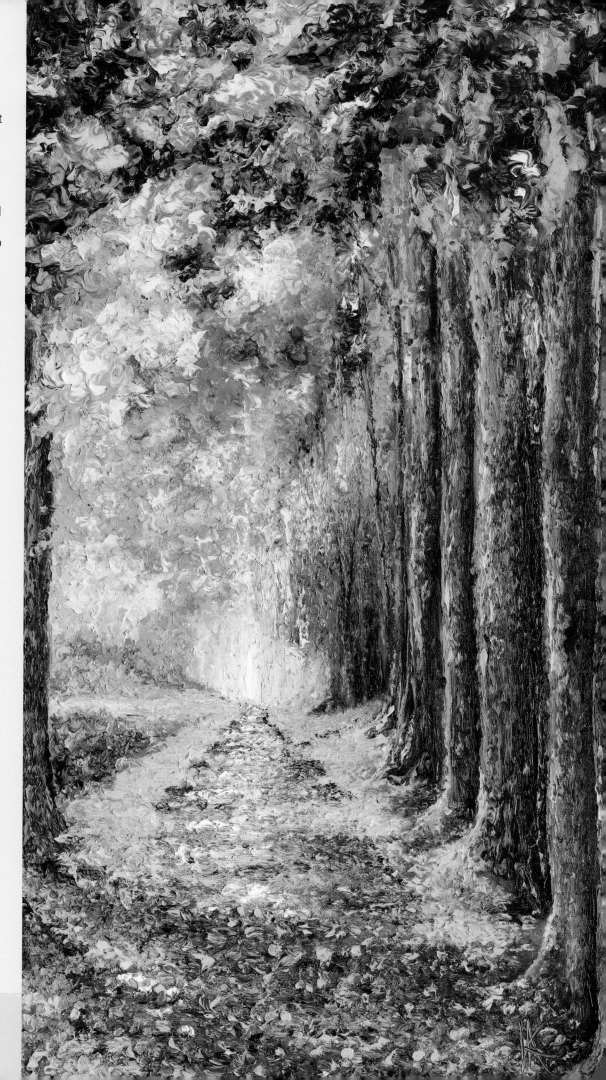

step 10

For the final touches, I add cobalt blue and mauve to the foliage at the top of the canvas. Then I add yellow-green, ice green, and titanium white over the misty blue at the horizon line to finish shaping the trees. I gradually add yellow-green and ice green to the top of the canvas to break up any large dark areas, smoothing out the hard edges. I add more cadmium yellow to the pathway and a hint of luminous opera to lead the eye down the path.

aspens in the fall

FALL IS AN EXTRAORDINARY TIME OF YEAR—the colors of the leaves are so vibrant and crisp! It's one of my favorite landscapes to paint. Painting in an impressionistic style allows an artist to paint the fall landscape of his or her choice. Here I chose a landscape full of color and texture.

step 1

I position the canvas vertically and divide it into three sections from top to bottom. Using a pencil, I sketch where I want my trees to line up at the bottom of the canvas, spacing them so that the composition is off-center.

Now I fill in the sections with a light layer of mauve. I use my fingertip to sketch the horizon line toward the bottom of the canvas.

I add a very thin layer of lemon-yellow to the top left, leaving a white area of canvas. Then I add cadmium yellow light followed by cadmium yellow and blend. Next I add vermilion and blend until it touches the mauve. To the right I add rose-violet, blending it into the mauve and vermilion. Then I use cadmium yellow to fill in the white space.

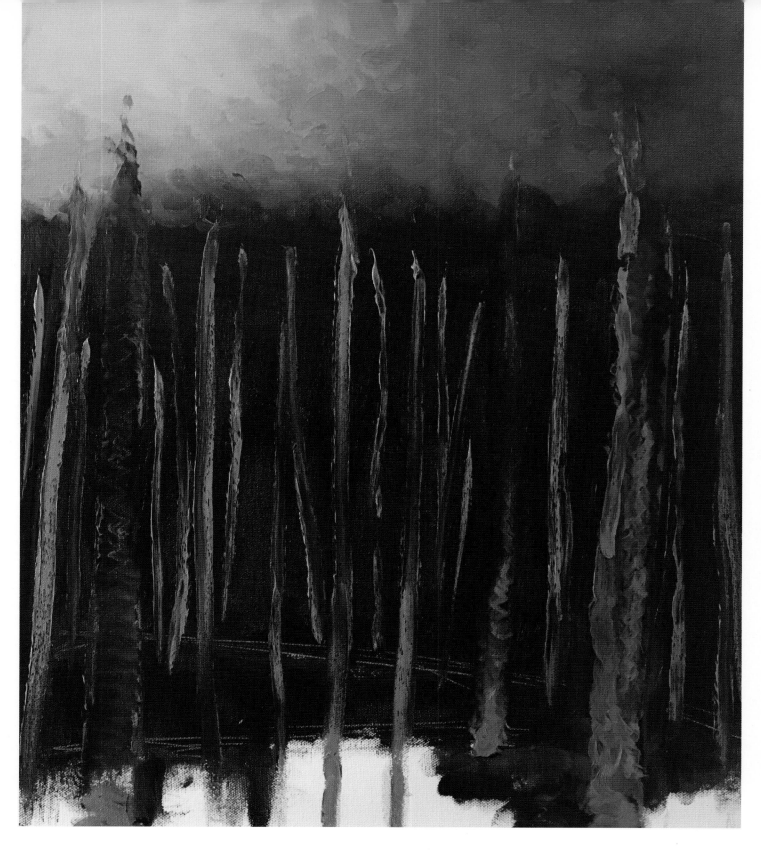

step 2

Using the penciled area as a guide, I make vertical lines with lavender. I overlap the lines somewhat, purposely avoiding any straight lines to create a natural feel. The sizes of the trees should vary, and I place some at a slight angle.

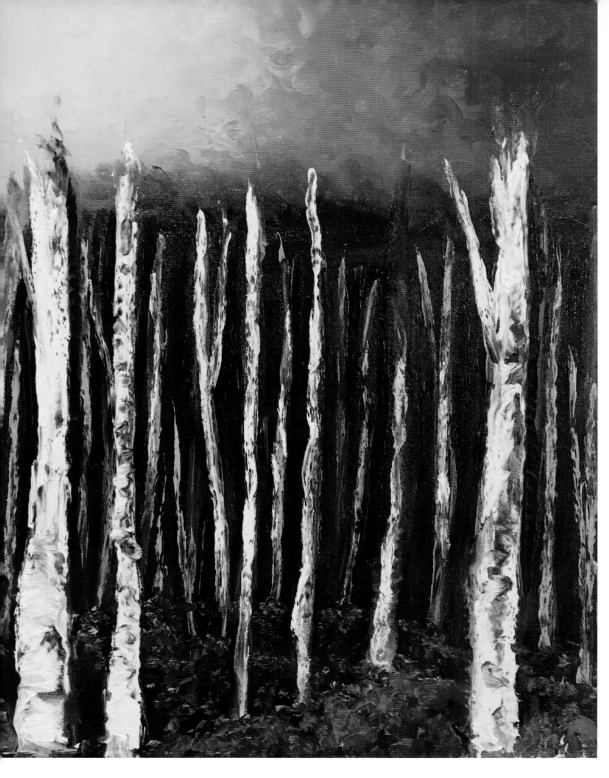

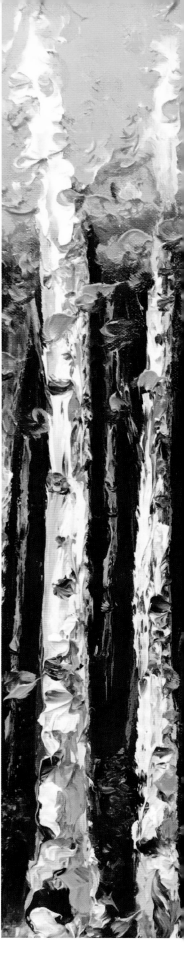

step 3

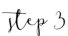

I define the trees in the background by painting horizon blue on top of the lavender in light, vertical strokes. I select three of the largest foreground trees and place misty blue paint in small, horizontal strokes, moving from the bottom of the canvas to the top. Then I add misty blue to a few of the trees in the background to give the illusion that light shines on them. I use mauve to define the edges and darken the areas between the trees.

To create the effect of fallen leaves, I add vermilion to the horizon line. I place larger paint swabs at the bottom of the canvas, and then gradually get smaller toward the center.

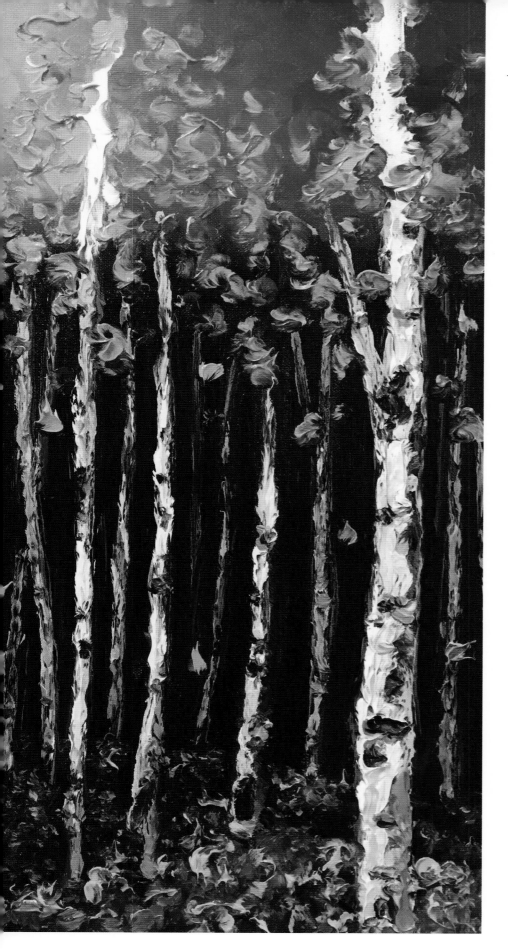

step 4

To create depth in the foreground, I highlight the vermilion with cadmium yellow. Then I add more texture to the foreground trees with Naples yellow, yellow ochre, and imidazolone brown. Then I add lavender and horizon blue to the right of each trunk and finish by adding titanium white to the areas that I want to be the brightest.

I create aspens' trademark knots with yellow ochre and imidazolone brown. Then I extend the largest tree trunks to the top of the canvas by adding titanium white and misty blue.

I apply thick touches of cadmium yellow to the leaves at the top of the trees.

Avoid touching the canvas in the same place twice to prevent the colors from mixing too much and looking muddy.

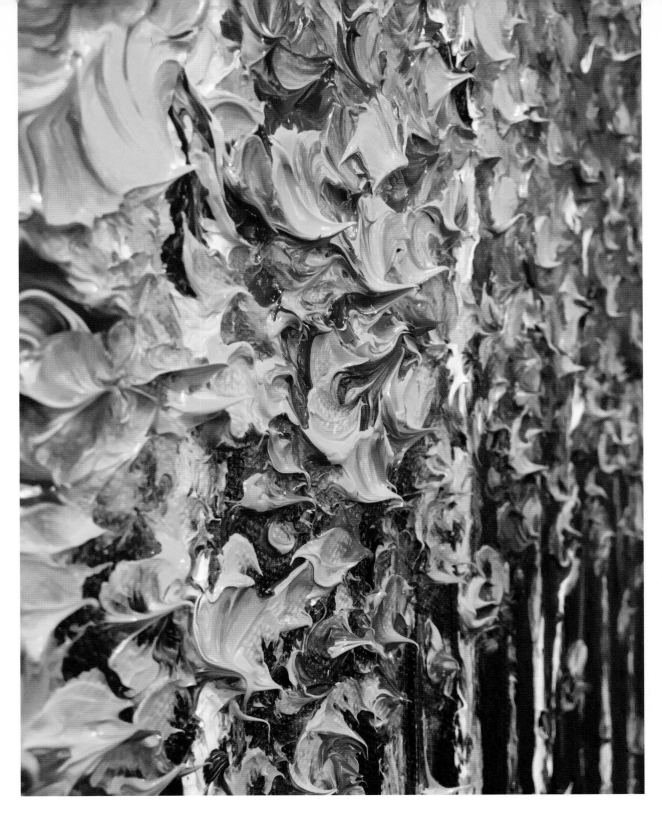

Step 5

I continue to add texture to the leaves by adding rose-violet to the right side of the canvas toward the top center and then adding cadmium yellow light from the left to the top center. I add vermilion to brighten the right side of the canvas. On the left side, I add lemon-yellow. I continue to build texture by adding more cadmium yellow, lemon-yellow, vermilion, and rose-violet to the top, allowing the paint to swirl and create peaks. Then I add subtle white branches extending from each tree. Near the base of the trees in the background, I add yellow-green to soften the shadows and finish the painting.

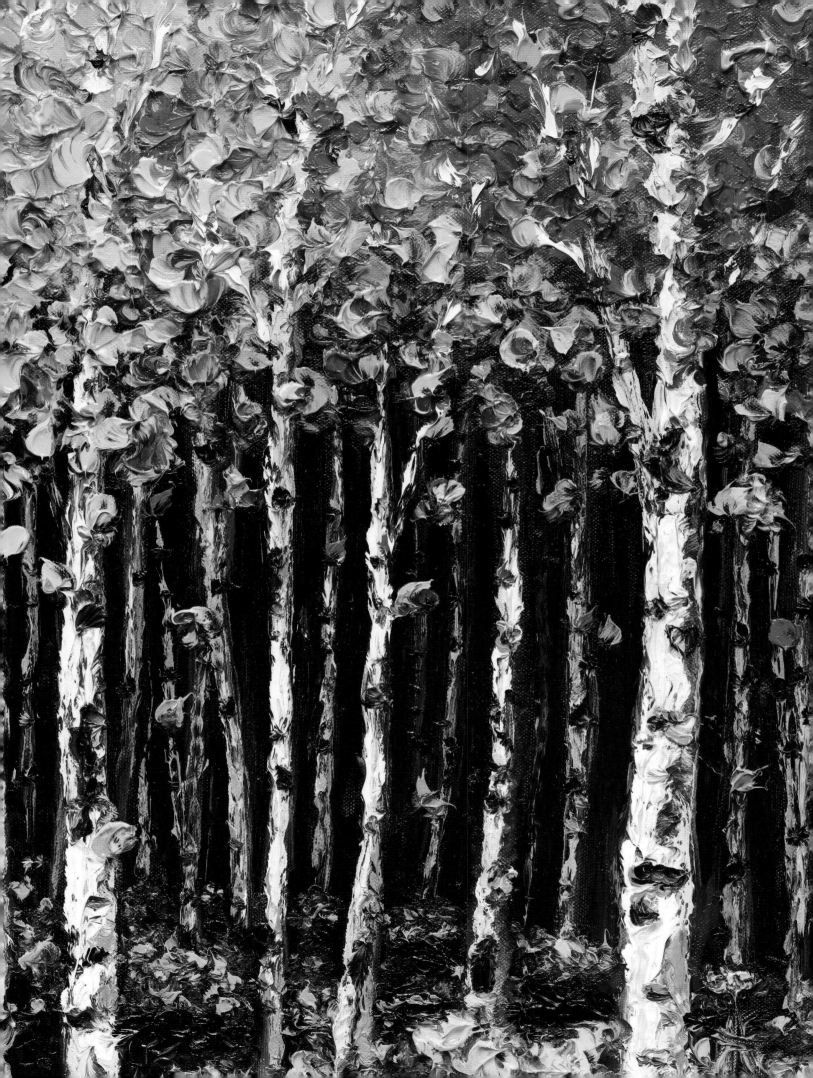

wildflowers

WILDFLOWERS TAKE CENTER STAGE IN THIS VIBRANT LANDSCAPE. I used several textural effects to create the flowers and produce a three-dimensional illusion. The cooler colors of the trees make the bright and colorful flowers the focal point.

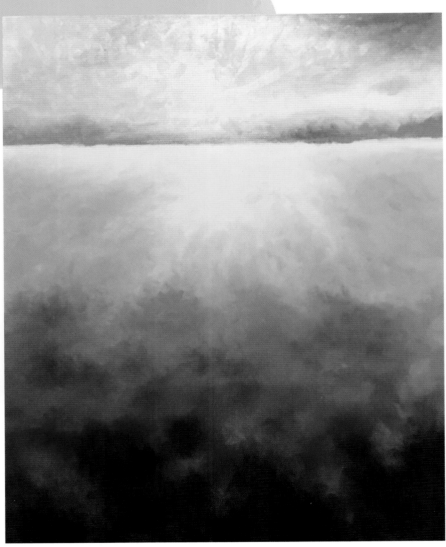

step 1

Divide the canvas into four horizontal sections. Starting with the top, I apply an even, light wash of misty blue. Below that, I add Naples yellow, painting in a V-like shape toward the center of the canvas. Next I add yellow-green to fill in the space around the yellow. Then I use horizon blue and cadmium green in large patches. Finally, I add mauve to fill in the bottom. I leave some white showing through.

step 2

I blend ice green into the hard edges of paint, allowing the colors to mix. My goal is to create a nice wash effect.

At the base of the top section, I add lavender from the right side moving toward the center. I add horizon blue from the left side and move toward the center, blending into the lavender. I add lilac just above the center.

I continue to add lilac, ice green, and Naples yellow into the misty blue at the top and I soften any hard edges. I add verditer blue to the top right.

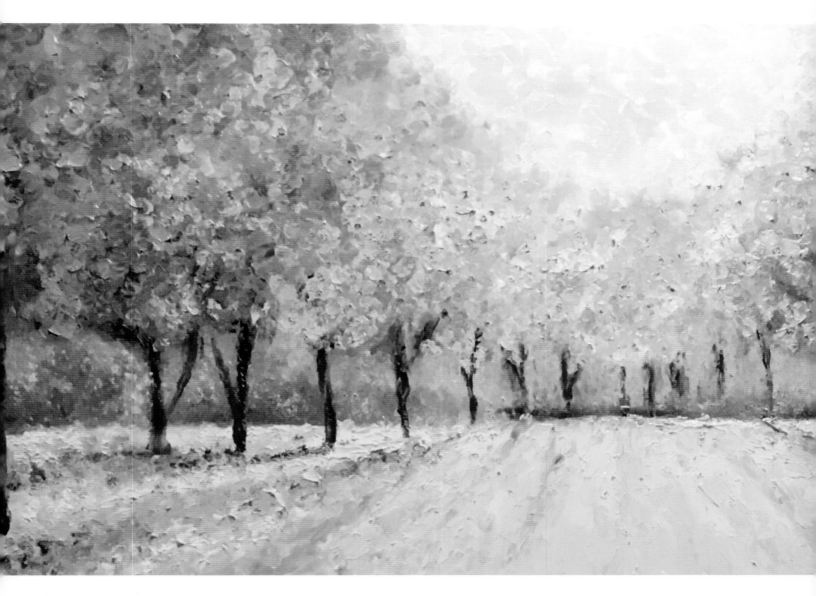

step 3

Starting from the top corners of the canvas and moving toward the center at an angle, I add phthalo green in small, circular motions. The closer I get to the center, the smaller I make the circles. I add verditer blue and ice blue on top to add depth and create foliage. I use Naples yellow and ice green toward the center. Next I add rose-violet and cadmium yellow to create bushes under the trees, and use ice green to add highlights. I add tree trunks by painting mauve and lavender in vertical strokes.

Building layers is the key to achieving texture. Adding too much paint in the beginning can cause the canvas to look muddy.

step 4

Starting at the base of the trees, I add lilac, ice green, and cadmium yellow in rows to create shadows. I apply the paint starting from the baseline under the trees and moving to the outer edges of the canvas at an angle. I add horizon blue and lavender from the bottom corners of the canvas toward the center.

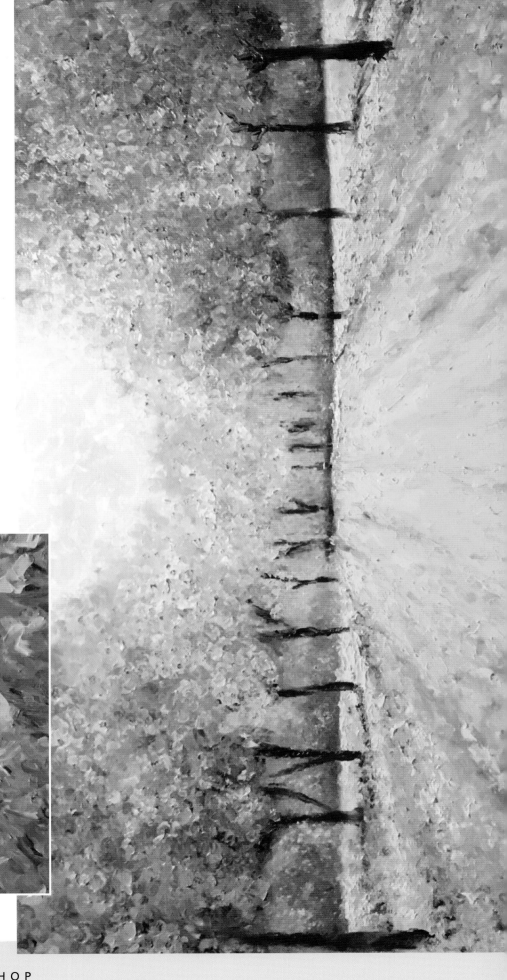

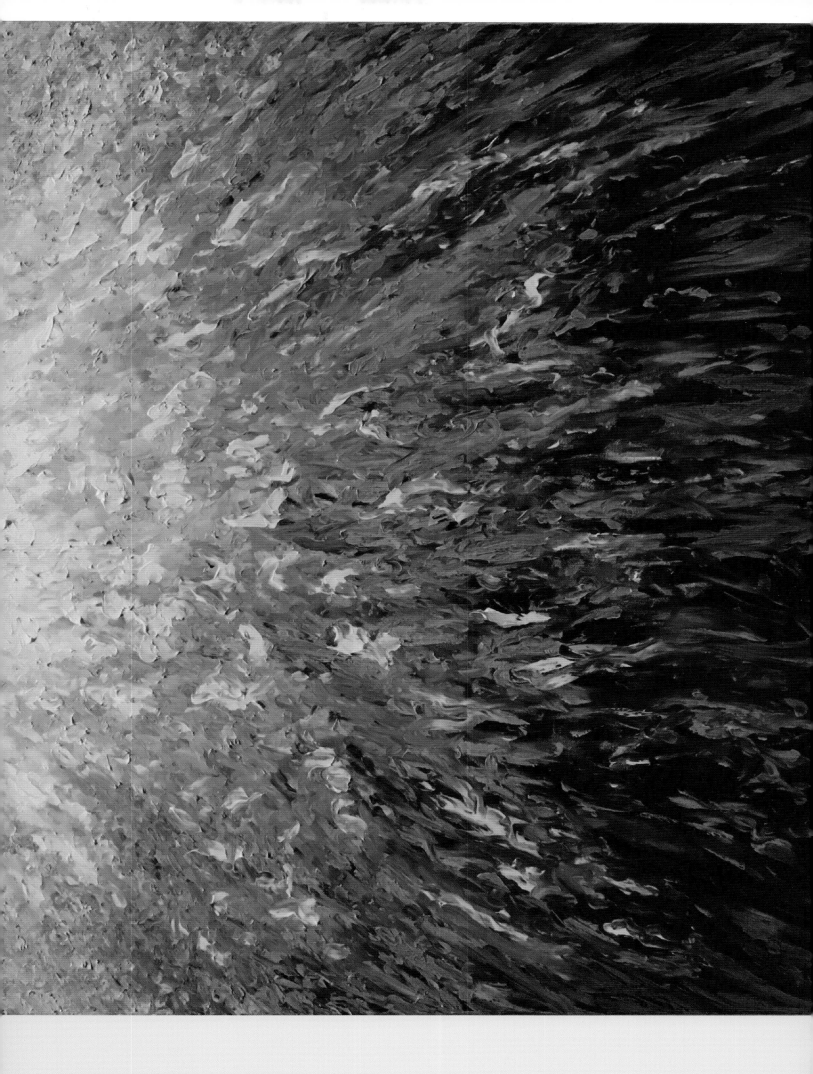

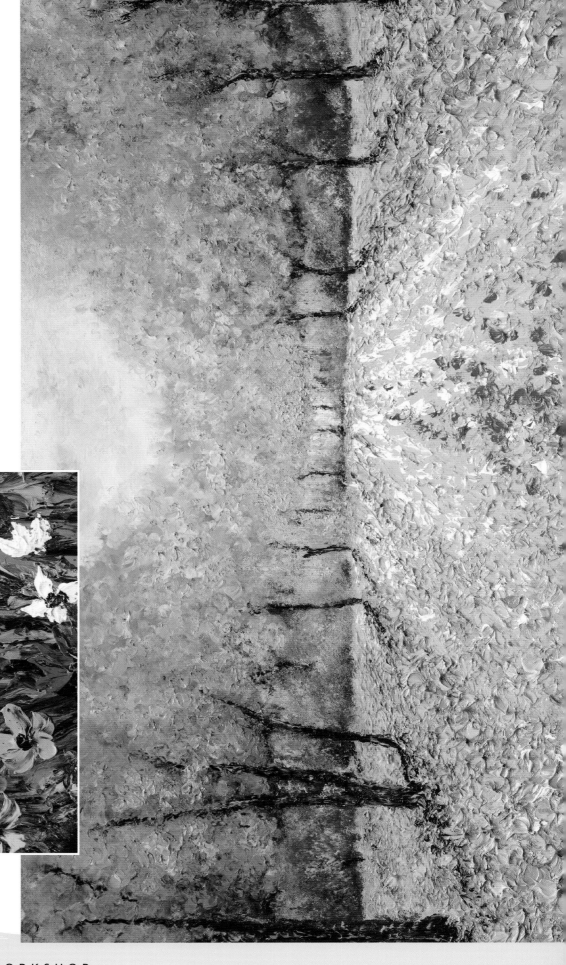

Step 5

I paint the larger, more detailed flowers at the bottom of the canvas. As the flowers fade into the distance, I paint them smaller. For the more detailed flowers, I use rose-violet, and add vermilion and cadmium yellow for highlights. After I create the petals, I add a dot of mauve in the center of the flower and add verditer blue. I create white flowers by adding misty blue as the base and titanium white as highlights; I also use mauve and verditer blue in the center of these. For the blue flowers, I use horizon blue as a base and ice green as a highlight. I create the yellow flowers with cadmium yellow light and lemon-yellow. I add red flowers with vermilion. For the final touch, I add cadmium yellow to the tree trunks and a few more details to the bushes and trees.

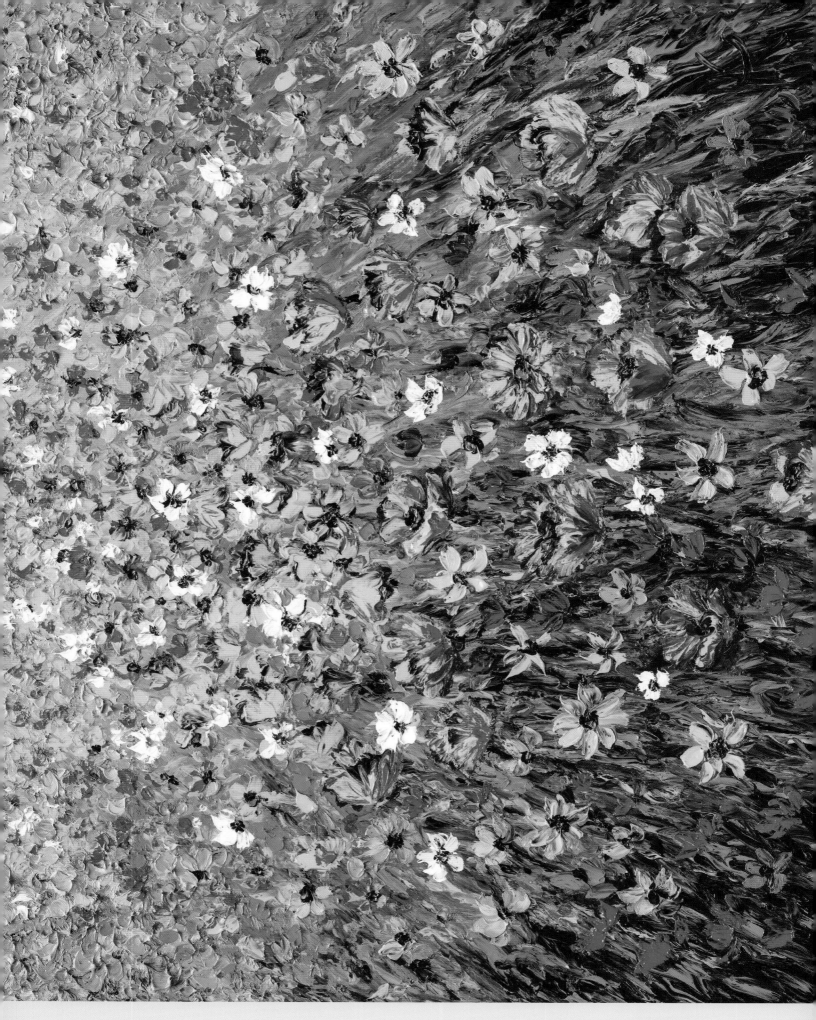

autumn pathway

THERE IS SOMETHING NOSTALGIC AND FAMILIAR ABOUT AN AUTUMN SCENE.
In this painting, we will create an impressionistic landscape with vibrant fall foliage along a cozy pathway. Balancing both cool and warm colors, this scene invites the viewer to reminisce about the crisp air and never-ending colors of autumn.

step 1

To begin, I apply a thin wash of misty blue along the horizon line and to three of the four corners of the canvas.

step 2

I add horizon blue to the top two corners and the bottom left. Using the tip of my finger or a palette knife, I sketch into the paint where I plan to place tree trunks. Starting at the horizon line, I use yellow-green and paint in a zigzag motion to create a path. Next I paint puzzlelike shapes in Naples yellow to indicate treetops.

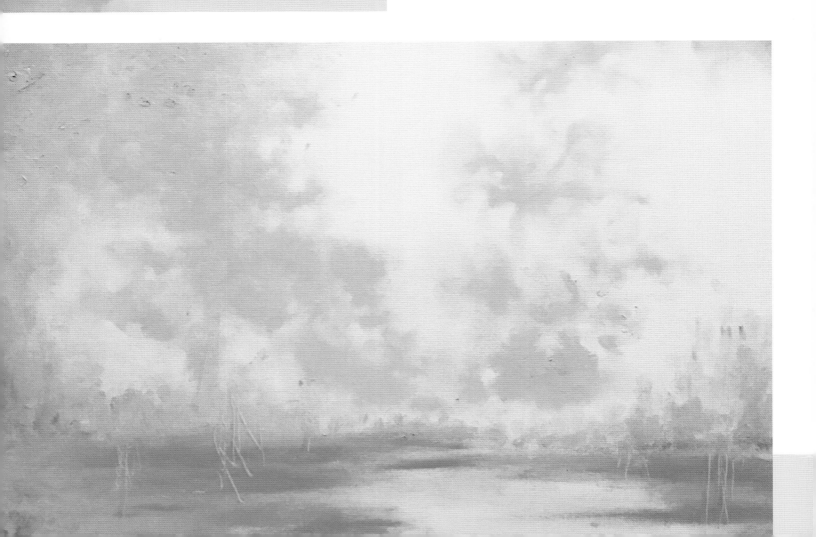

step 3

With cadmium yellow, I add a shadow under each of the areas where I painted Naples yellow. I add rose-violet below the cadmium yellow, filling in any large areas where the canvas shows through. Then I eliminate hard edges by blending. With misty blue and titanium white, I fill in between the tree foliage. Lastly, I use yellow ochre to shade the pathway, following the zigzag shape.

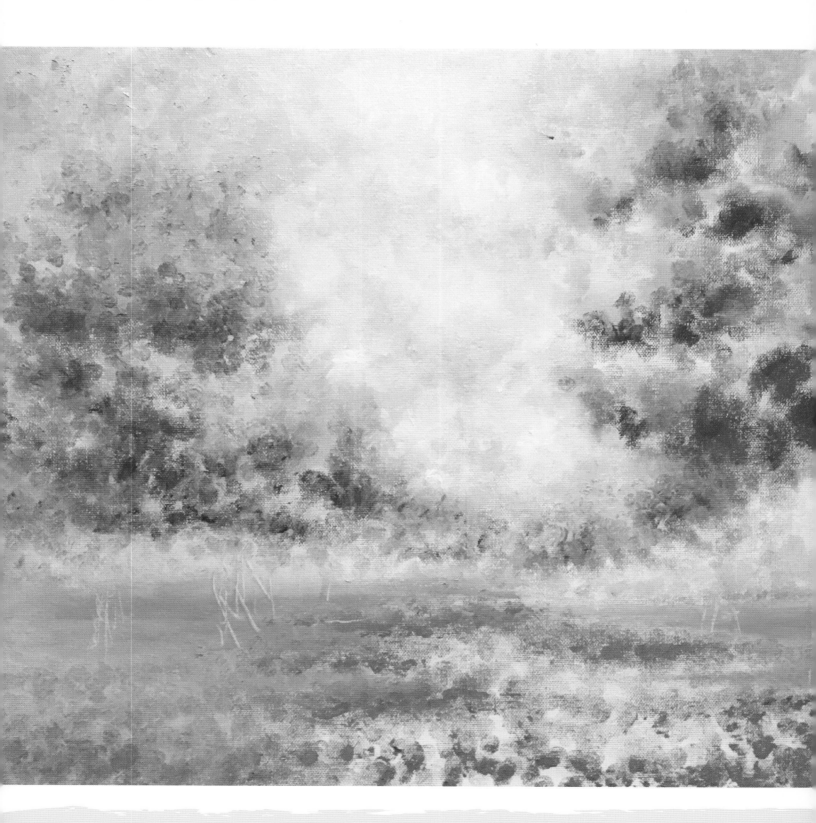

step 4

Along the right and left sides of the tree foliage, I add more rose-violet, leaving the center of the canvas lighter. Moving to the pathway, I add imidazolone brown into the yellow ochre, finishing with a subtle highlight of Naples yellow down the middle of the path.

I paint the tree trunks with imidazolone brown. I paint each a slightly different shape. The trees in the foreground are large; they become smaller as they fade into the middle of the canvas. Shifting to the pathway, I add jaune brilliant and misty blue to create highlights.

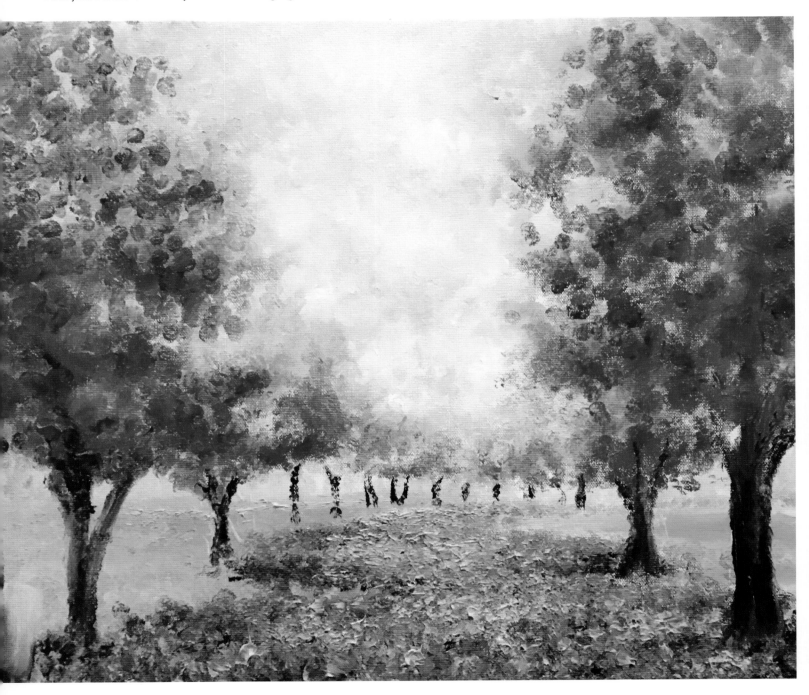

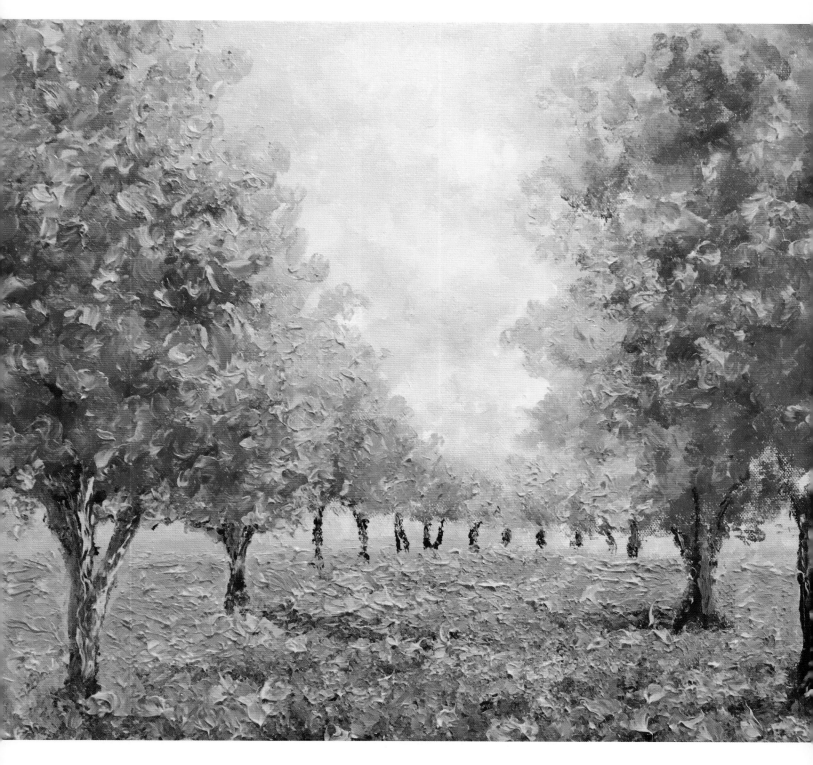

step 5

With lavender, I add shade to each of the tree trunks on the side opposite the path. I use Naples yellow to highlight the tree trunks closer to the pathway. This creates a glow. To add highlights to the meadow, I add ice green into the yellow-green in small, oval shapes. Next, I add highlights to the tree foliage by swirling cadmium yellow light into the rose-violet. Lastly, I add a few dabs of cadmium yellow to represent fallen leaves.

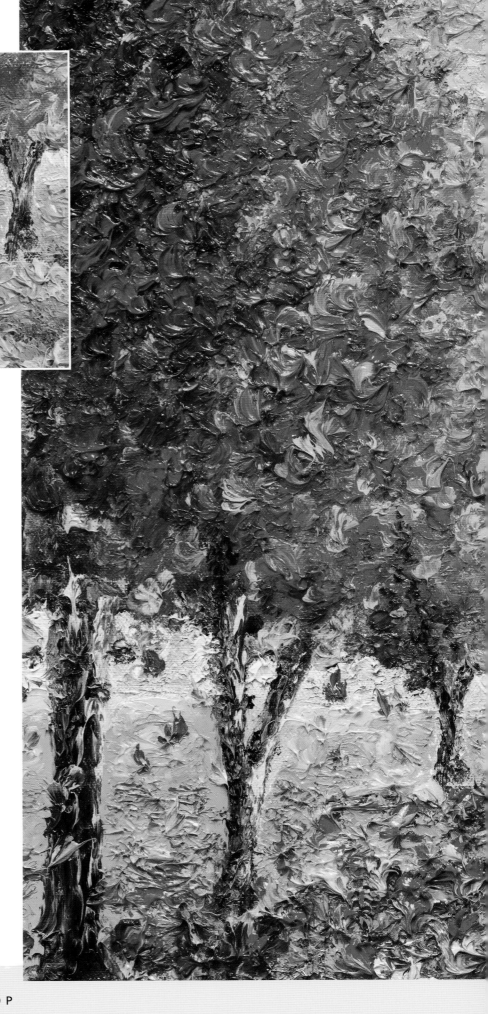

step 6

For the final touches of texture, I build swirls of rose-violet and cadmium yellow into the tree foliage. I blend lemon-yellow into the center trees to lighten that area. I also add dabs of lemon-yellow along the pathway and the horizon line. Then I add dabs of rose-violet and vermilion to the fallen leaves to suggest depth. Down the center of the path, I layer in misty blue, lilac, and titanium white. Lastly, I stand back and add colors until the landscape looks nicely balanced.

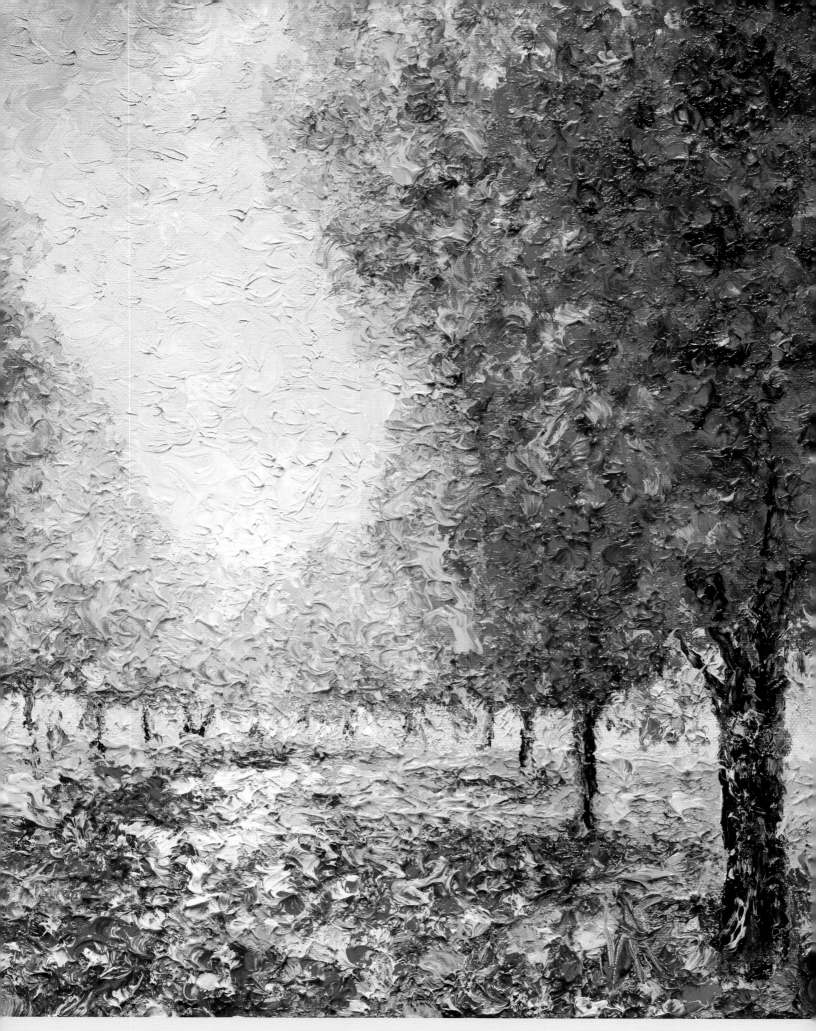

bridget skanski-such

As a child, Bridget Skanski-Such dreamed of a life in the countryside. She finally realized her dream when she moved to a little village in rural Lincolnshire, England. The changing seasons and the natural world became constant inspirations to her as she watched flora and fauna alter around her throughout the year.

After studying for her degree at Nottingham Trent University, Bridget taught for 32 years, specializing in art education and education management. She ran two primary schools, and then left full-time teaching in 2001 to join an artist cooperative, where she began exhibiting and selling her paintings. Her greatest joy is to be at home in her studio, engrossed in her work. She loves to work in acrylics, producing layer upon layer of color and pattern, and likes the forgiving nature of the medium. Bridget uses various tools in her paintings—even her fingers—to brush, stipple, print, and spatter.

A musician as well as an artist, Bridget is committed to a philosophy of lifelong learning and the life-affirming effects of creative endeavor. She exhibits at Lincoln Artists' Market and at other local and national events in England.

Learn about Bridget's work at www.facebook.com/bridgetskanskisuch.art.

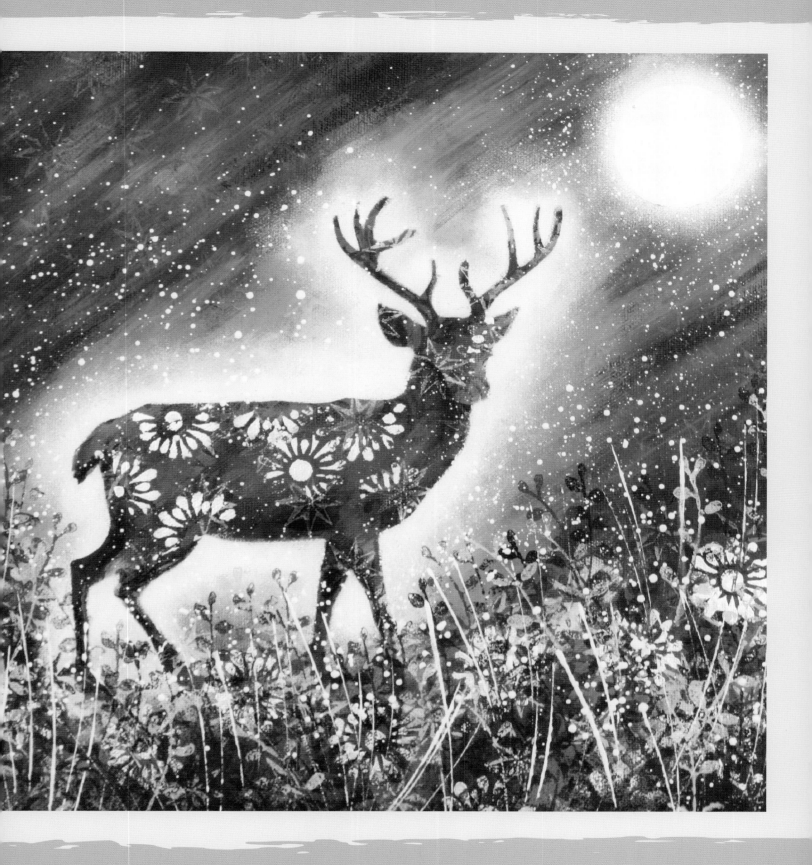

tools & materials

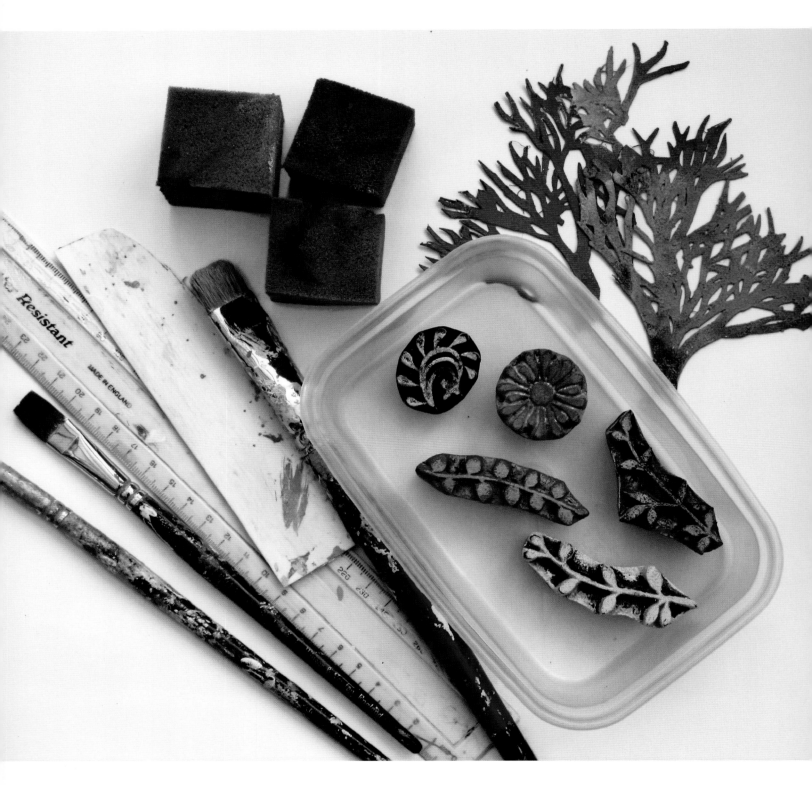

Canvas

I like to use square, deep-edged box canvases for my work. I don't frame my work because I think it looks more contemporary without a frame.

Paints

I like to work in acrylics. My background is in textiles, so I enjoy layering and glazing with transparent colors and acrylic glazes. Acrylic is a flexible medium; you can paint over areas that are unsatisfactory and it dries quickly, allowing you to build up layers of color and pattern over a short time.

There are many good brands of paint on the market. Professional-quality paints are more concentrated and vibrant in color.

Varnish

I usually spray my paintings with varnish to protect them when they are finished. I use either matte or gloss varnish, depending on what I think will best suit the piece.

Paint can be expensive, but investing in quality materials enhances the overall quality of the work.

Painting Tools

I like to use a variety of tools besides brushes to apply paint. My favorite tools are small sponges that I use to apply paint to printing blocks, for stenciling, and to apply paint directly to the canvas.

I often include elements of print in my work. I use strips of plastic that I cut from food containers and the edges of flexible rulers to print grasses and plants. I also have a collection of carved wooden printing blocks. Printing blocks are readily available online and are great for adding pattern to your paintings.

Containers

I tend not to use a palette. Sometimes I need my paint to be very liquid, so I prefer to use disposable food containers. I usually use several while completing my artwork. I wash the containers out as I go and use them repeatedly.

Easel

I don't often work on an easel because it's important to keep paintings flat when using the spattering technique. (If you tip your canvas, your spatters will run!) However, if I'm working on a larger piece, it's necessary to use an easel between stages to view the work from a distance and make judgments about its progress.

Brushes

Like most artists, I have a collection of favorite brushes—even some that are very old and battered! However, I replace very fine brushes regularly to keep a good point on them.

Stencils

I like to use stencils in my work, and I make my own using thin card stock. First I draw the design with a pencil, and then I carefully cut it out with a craft knife or scalpel. It's quite a painstaking process, but if I allow the stencils to dry after I use them and store them carefully, I can use them repeatedly. Sometimes I use my stencils for stenciling, and sometimes I use them as layout tools for setting out different elements on my canvas to see if a composition will be effective.

Cloths

I always have a cloth on hand to quickly blot away unwanted spatters or blobs.

techniques

I REGULARLY USE BLOCK PRINTING, STENCILING, AND SPATTERING in my work. These three techniques contribute to the individual style and character of my paintings. I have been using these techniques for some time now; they have become second nature to me and they seem quite easy. If block printing, stenciling, and spattering are new to you, I suggest you practice them before you use them in your own paintings.

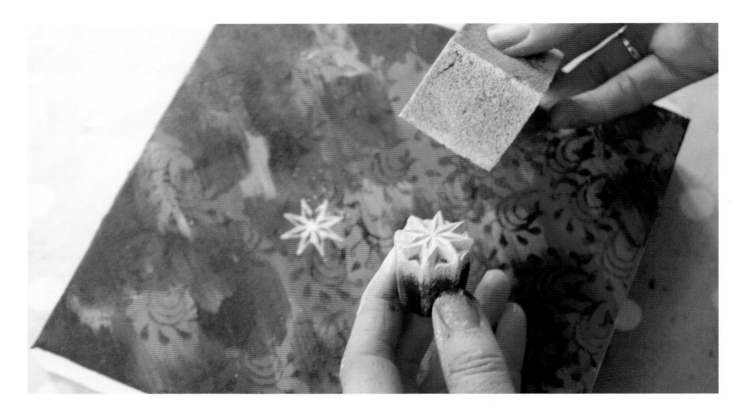

BLOCK PRINTING

Carved, wooden printing blocks can add lovely patterns and textures to your paintings. These blocks are available online in a huge variety of designs. Here's how I use them:

- I mix up my paint in a tub, dampen a sponge, and dip it in the paint.
- Then I dab the paint-laden sponge onto a printing block and apply the block to the canvas, taking care not to move it to prevent smudging.

Also, keep in mind these tips:

- Reapply paint to the block with the sponge before each print.
- If your prints are missing areas of paint or the block will not print, you need to moisten the sponge.

- If your prints don't look well-defined, your sponge and/or your paint may be too wet.
- Experiment by overlapping prints, using different paint colors, and using a variety of printing blocks to find the effects that you like best.
- Let each printed layer dry before applying the next one.
- You can print stems and grasses using the edge of a strip of plastic or a ruler. Mix the paint with water to make it runny, and then apply it to the edge of the strip or ruler with a brush.

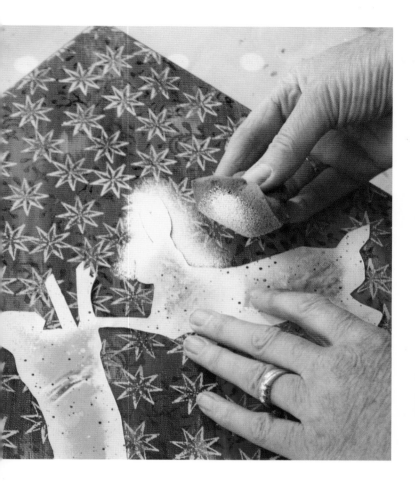

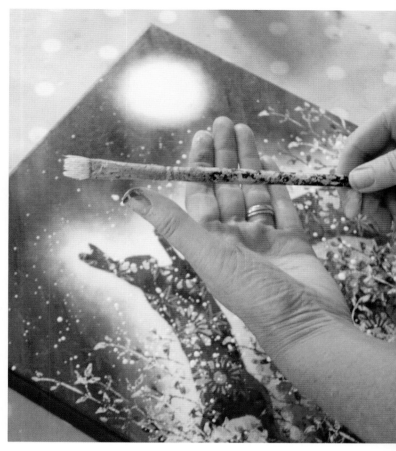

Stenciling

My paintings often feature an underpainting with complicated patterns and dark colors, and it can be difficult to draw accurately on top of a surface like this, so I use stencils. Here's how:

- I draw shapes onto thin card stock and cut them out carefully on a cutting board with a craft knife.
- I lay the stencils out on my painted background to plan the composition of a painting.
- Stencils work well as templates that I can draw around to put elements in place. I attach the stencils with temporary tacking adhesive and apply paint around them using a sponge.

Here are some tips for using stencils:

- When sponging around your template or stencil, use a very small amount of paint on your sponge.
- I like to use undiluted paint, or I wet my sponge with just a small amount of water. If the paint is too runny or there's too much on the sponge, the paint may bleed under the stencil.

Spattering

Spattering is not as random as you might imagine! Here's how I spatter:

- I mix paint with water in a plastic tub until the paint is quite runny. I mix this thoroughly.
- Then I load a brush with paint, hold the brush in one hand, and bring the handle down against the palm of my other hand.
- For big spatters, I use a big brush, and for small spatters, I use a small brush.
- I think about where I want my spatters to go. Occasionally, I use a piece of torn paper to keep areas of a painting free of spatters.
- I always place my canvas on a flat surface, and I keep it flat until my spatters are completely dry.
- Each layer must dry before the next can be applied or the colors will blend together into muddy tones.

poppy meadow

MY INSPIRATION IS THE COUNTRYSIDE AROUND MY HOME. I find the wild flowers on the roadside and in the meadows to be immensely romantic and magical subjects. I usually work from photographs to help my observation of shape, form, and color.

In this project, I'll show you how to create a painting featuring wildflowers and grasses. Then you'll be able to develop meadow paintings based on flowers from your own surroundings. I enjoy working on unprimed, deep-edged, square canvases, but you can use whatever format you feel comfortable with.

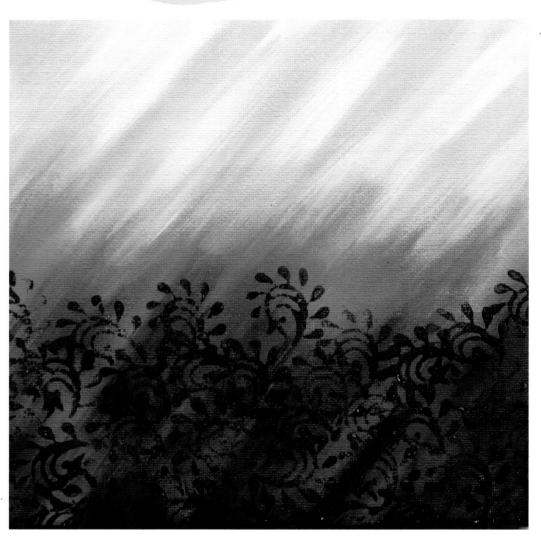

step 1

Begin by painting diagonal strokes using a broad, square brush. For the sky, I use acrylic paints in titanium white, brilliant blue, and black and very little water.

For the foreground, I use the same diagonal strokes in dioxazine purple, sap green, emerald green, and cobalt turquoise. When painting with acrylics, always let one layer dry before moving on to the next step.

Now add pattern to the foreground with a wooden printing block. Any organic, abstract design will work. I use a thin mixture of Mars black and ultramarine and apply the paint to the printing block with a sponge.

If you are using a deep-edged canvas, use leftover paint to cover the sides of your canvas.

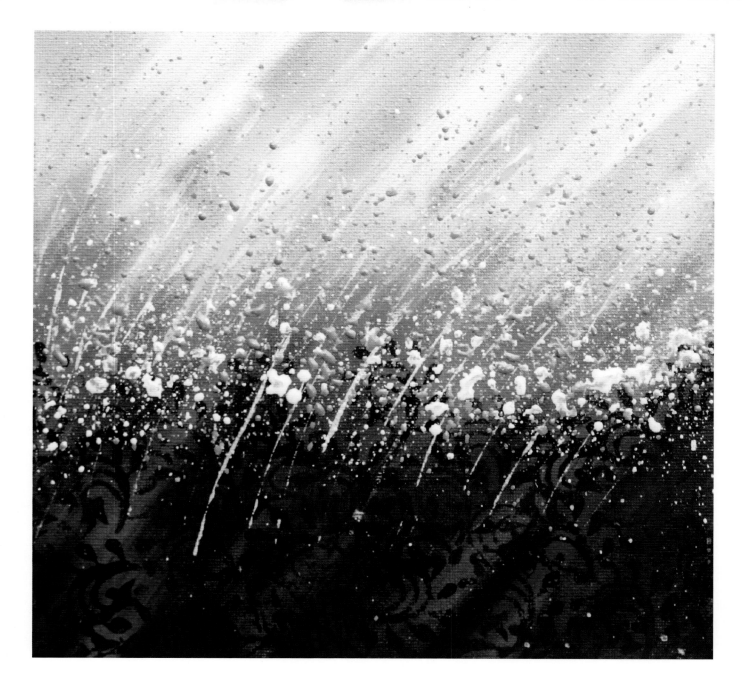

step 2

Next, print the grass stems. I like to use strips of plastic cut from food containers to print grass and plant stems. Using sap green mixed with titanium white, print the grass stems on a slant following the diagonal strokes of the background.

Remember that by following the rules of perspective, you can create depth in your paintings. The grass stems at the back of your painting should be smaller and paler than those at the front.

Spatter the area just below the top of the grass with titanium white and a thin mixture of cobalt blue and white. Blot away any large spots using a rag wrapped around the end of your finger.

Wash your brushes promptly after using them. This will lengthen the life of your tools, and your equipment will always be clean and ready for the next stage.

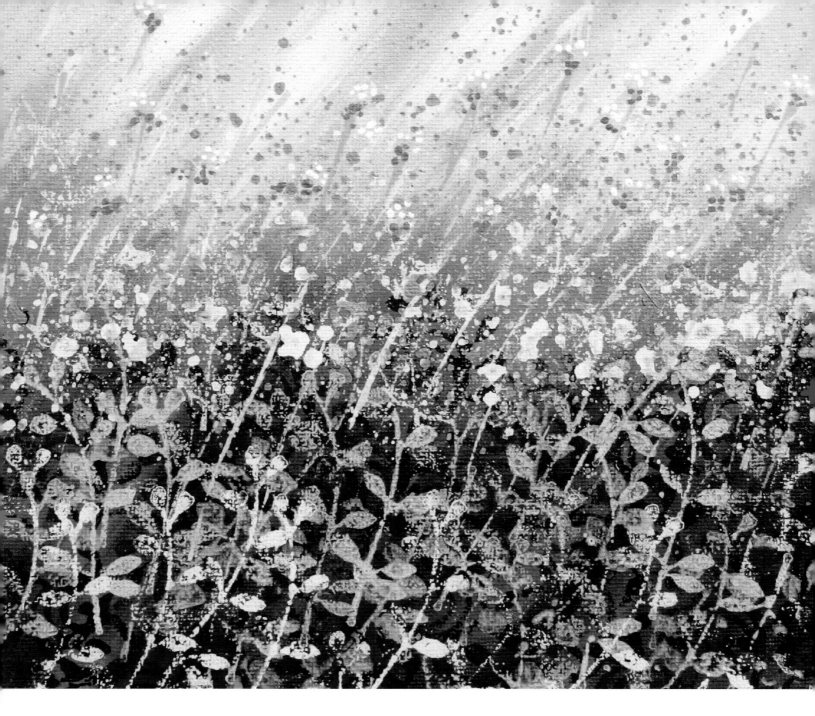

step 3

Add more tangled foliage to the foreground with printing blocks. Use a thin mixture of brilliant yellow-green and titanium white as well as a thin mixture of brilliant yellow-green, white, and cobalt blue.

Now add some flowers to the background. With a strip of plastic, print the stems using brilliant yellow-green mixed with a little white. With the end of a thin dowel, print flower heads using cadmium yellow light mixed with a little white. With a very fine brush, stipple white at the top of the little flowers.

At the base of the flowers, stipple a mix of cobalt blue and brilliant yellow-green. I add a little more spattering over the area where the background meets the foreground using cobalt blue and cobalt blue mixed with white.

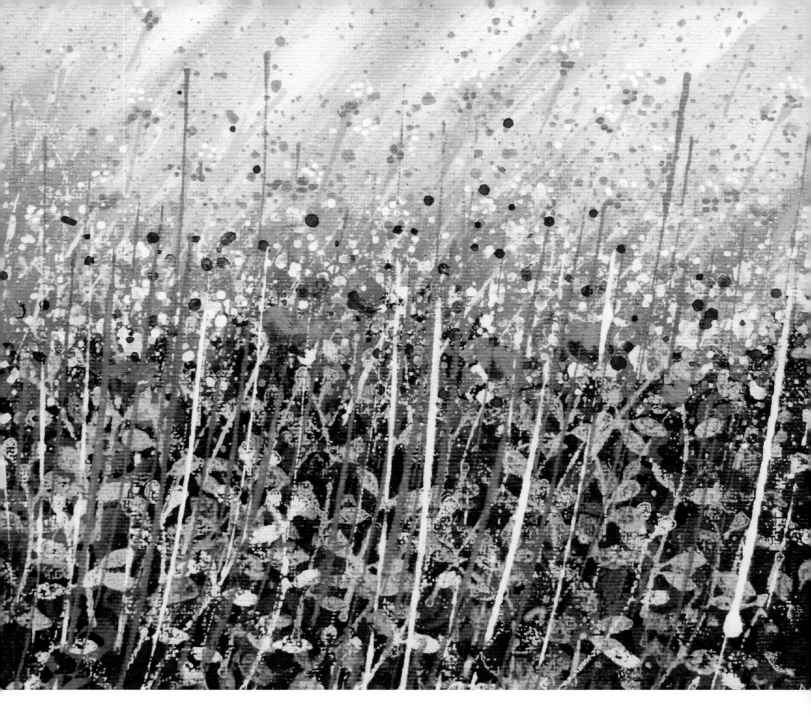

step 4

Paint the body of each poppy using cadmium red. These flowers are in profile; we can't see into their centers. I add shadow areas at the base of each flower using deep magenta mixed with some black.

Add more depth to your painting by printing some taller flower and grass stems at the base of the painting. I use my plastic strip to do this with a combination of brilliant yellow-green and cobalt blue. I also print some stems using just white. Overlap some of the poppies to increase the feeling of depth.

With the spattering technique, it's easy to smudge your work. Wait until the spatters are dry before beginning the next step.

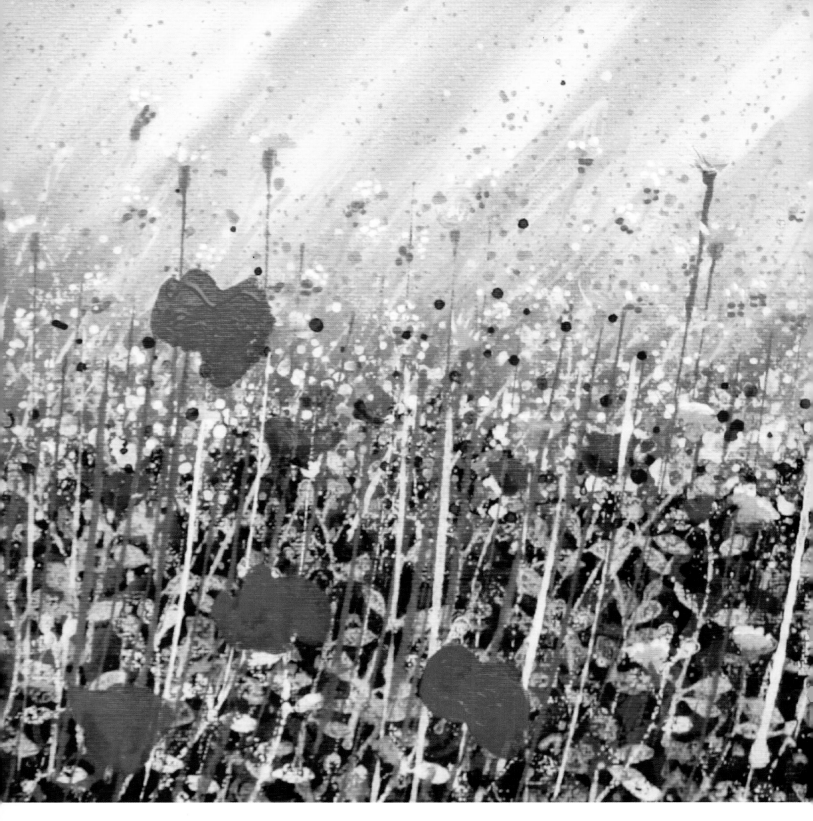

step 5

At the tops of the darker stems you just printed, paint yellow daisies with a fine brush and cadmium yellow light and medium hues. Add some white highlights at the tops of the flowers, and fatten out the stalks underneath each flower with a mixture of brilliant yellow-green and cobalt blue.

Now you can work on the foreground of your painting and add larger poppies. Begin by painting the shapes in cadmium red.

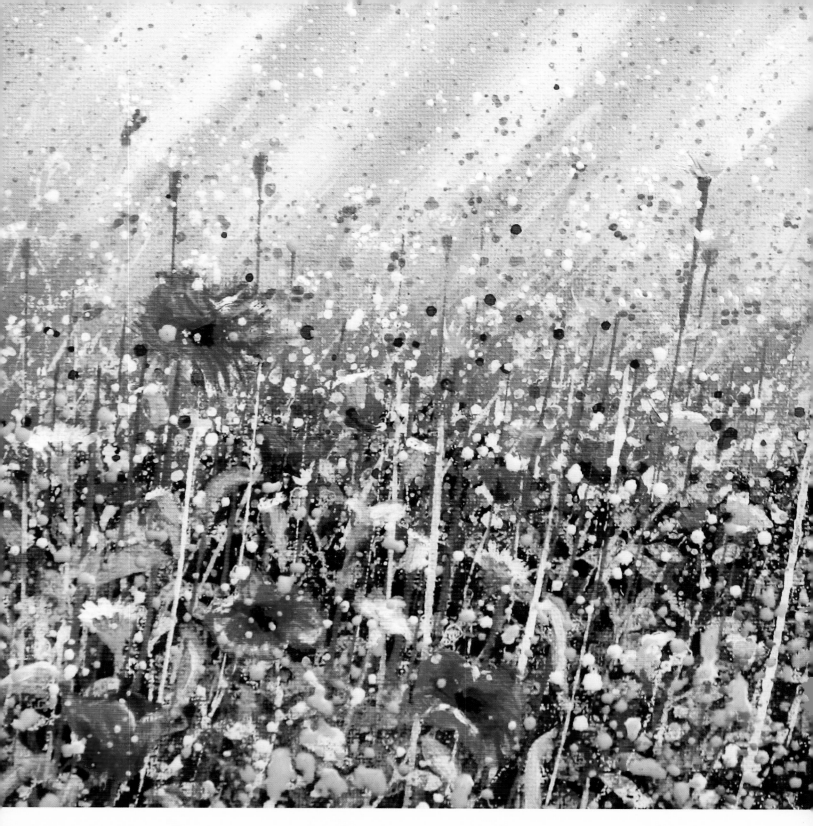

step 6

Paint the centers of the poppies black, and use a mixture of pyrrole orange, cadmium yellow medium, and white for the lighter areas. Poppies have shiny petals, so add white highlights. At the tops of some of the stalks, add small cornflowers using white and a mixture of cobalt blue and white. Paint the tops and outside edges of the flowers white, and fatten out the stalk underneath each flower. Add some leaf shapes to the foreground using a mixture of brilliant yellow-green and white. Finish the painting by adding spatters of white, brilliant yellow-green, and a mixture of white and cobalt blue.

daisy rush

I AM ALWAYS IN AWE OF THE NATURAL WORLD AROUND ME. I love seeing the countryside change with the seasons, and after a cold, gray winter, it is wonderful to see the hedges spring forth into life once more. Here in rural Lincolnshire, the early summer hedges are full of tangled oxeye daisies. These flowers have a romantic appeal to me, and I enjoy including them in my work. In this project, I will help you create a piece that features a tangle of daisy stems blowing in the breeze with a mist of pollen and dewdrops.

step 1

With a broad brush, paint the sky in the upper half of the canvas using diagonal strokes. I use titanium white and cobalt to create a light blue; white and black to produce a pale gray; and white, black, and brilliant blue to produce a pale gray-blue. I moisten the brush slightly to blend the different shades.

Using the same technique, apply paint to the lower half of the canvas. This time I use mixtures of dioxazine purple and white, and cobalt turquoise and white. Vary the shades and blend.

step 2

Now use a printing block to create a pattern on the lower half of the canvas. Dip a sponge in a thin mixture of black and ultramarine paint, and then apply the paint from the sponge to the printing block before each print. Any abstract, organic design will work well for this project.

When using a printing block to create pattern in your work, turn the block slightly in your hand before each new print. This will create a more random effect.

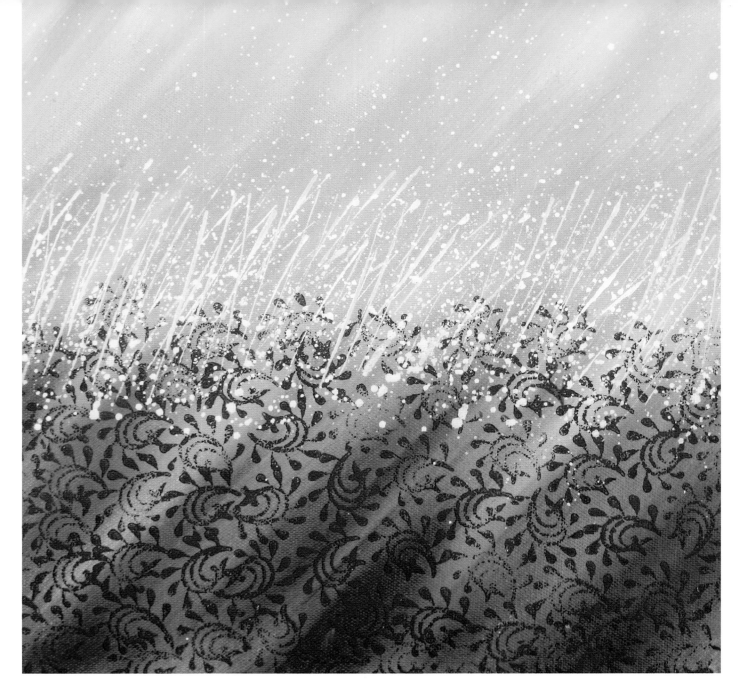

step 3

With a strip cut from a plastic food container, print grass stems on the horizon. For the background grass, I use a mixture of sap green, white, and brilliant yellow-green. These stems are at the back of the picture, so they need to be shorter than the stems in the foreground. Print the grass stems on a slant to suggest a breeze. Add spatters to the sky and horizon with thin, white paint.

Printing with a plastic strip can be tricky. If your print is not successful, try thinning the paint with a little water, and then apply the paint to the strip using a brush or sponge.

step 4

Now I create the suggestion of out-of-focus daisies. Stipple slanted ovals onto the foreground with a broad, stiff brush and white and light cadmium yellow. Do the same with a mixture of cobalt and white to create the out-of-focus blue cornflowers. To achieve a misty effect, use a tiny amount of undiluted paint on the tips of the bristles, and then remove the excess paint with a rag before stippling. Wash and dry your brush thoroughly before changing colors.

With a plastic strip and a mixture of black, white, and sap-green paint, create tall stems in the foreground. Add movement to the painting by varying the length of the stems and printing on a slant.

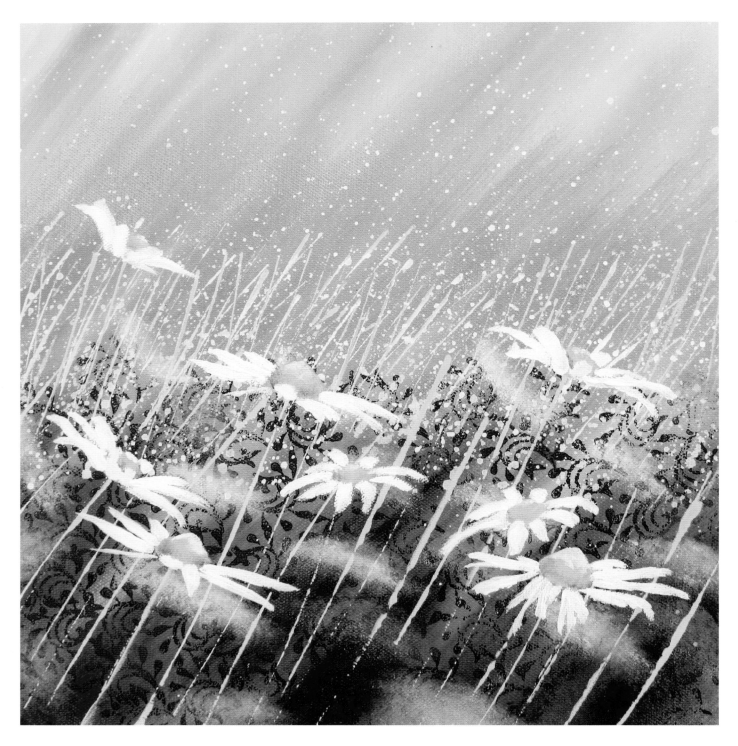

step 5

Now paint the daisies. I begin with the centers, using light cadmium yellow and a small, flat, square brush. Then I add the petals in white. When the yellow centers have dried, stipple a little white paint on the top of each one to add highlights. I also stipple a little medium cadmium yellow into the flower heads. Create a shadow at the base with sap green mixed with brilliant yellow-green. Paint the calyx, which supports the flower underneath the petals, using a mixture of sap green, white, and brilliant yellow-green. Then use the same color mixture and a soft, fine brush to add long, thin leaves growing from the daisy stems.

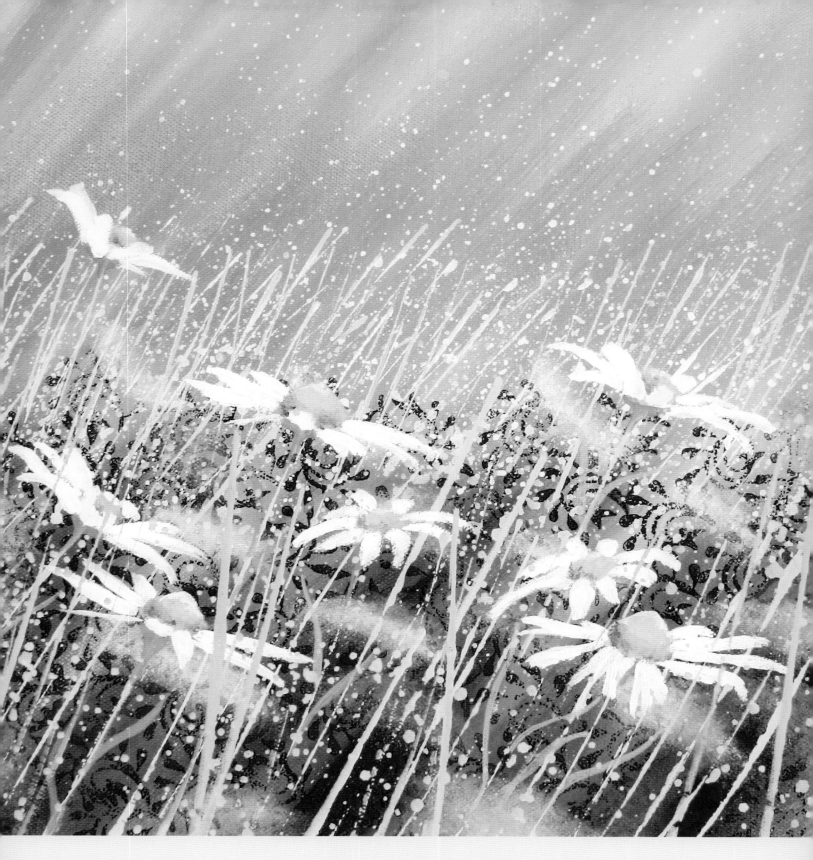

step 6

Add more grass stems to the foreground using a mixture of sap green, ultramarine, and white as well as white mixed with a small amount of ultramarine and brilliant yellow-green. Let these overlap some of your daisies. Add paint spatters to the foreground using the same shades.

big rock candy mountain

A FEW YEARS AGO, I PLANTED A FRUIT ORCHARD ON MY PROPERTY. The trees are still quite young, but they have already inspired a few paintings. In this project, I'll show you how to use layers of spattered paint to create a little glade of blossomy trees. Spattering is a fun technique, but it is not quite as random as you might imagine—you still need to consider each color and control the shapes that you are creating. This painting is titled "Big Rock Candy Mountain" because the finished candy-floss trees remind me of a song I used to listen to as a child.

step 1

Apply a base coat of brilliant blue mixed with white to the upper three-quarters of your canvas with a large, flat, square brush. Apply the paint in patches of diagonal strokes, and vary the mixture. I use undiluted paint except for a little moisture on the brush when blending areas of different tones. For the area nearest the horizon, I use more white in the mixture; for the lower quarter of the canvas, I mix brilliant blue with white and black. Blend with a slightly wet brush, and then let your canvas dry.

Now I'll create a pattern on the foreground at the lower quarter of the canvas. Using a thin mixture of brilliant blue, black, and white, apply the paint to a wooden printing block with an abstract, organic design.

Before applying the block print to your painting, try the technique on a piece of paper to make sure it comes out clean.

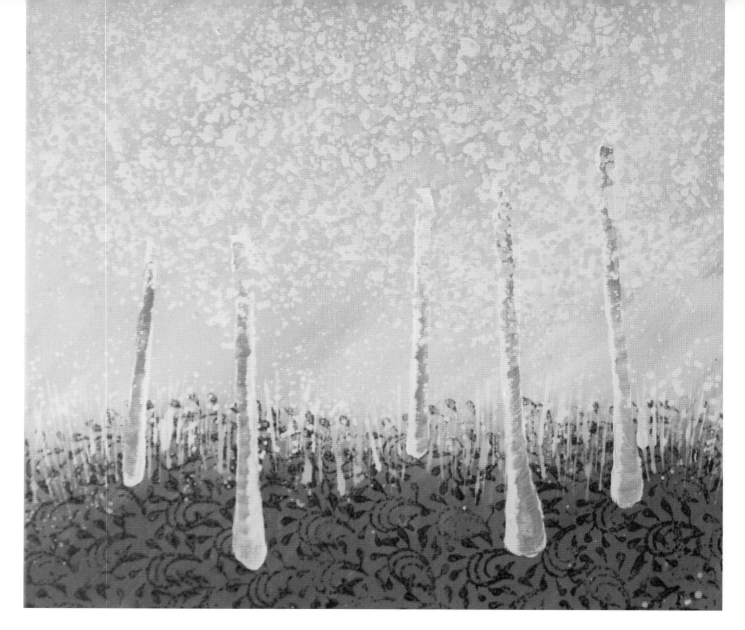

step 2

I cut out the shape of my tree trunks in stiff paper and try them in various positions before painting them.

To give your work depth, follow the rules of perspective: Trees near the viewer need broader trunks, and the base of those trunks will be nearer to the lower edge of your painting. I use my cutouts as a guide.

Paint your tree trunks titanium white using a small, flat-edged brush. Use a little gray to darken the shadowed side of the trunks.

Place your canvas on a flat surface. With titanium white, spatter the area where you want the foliage to be.

With thin, white paint and a short strip of plastic, print some grasses on the horizon, and then add more white spatters. Let this layer dry. Add a second layer of spattering with brilliant yellow-green mixed with white. Use this same color to add more grasses and spatters.

When spattering, remember that the more paint there is on your brush, the larger the spatters will be.

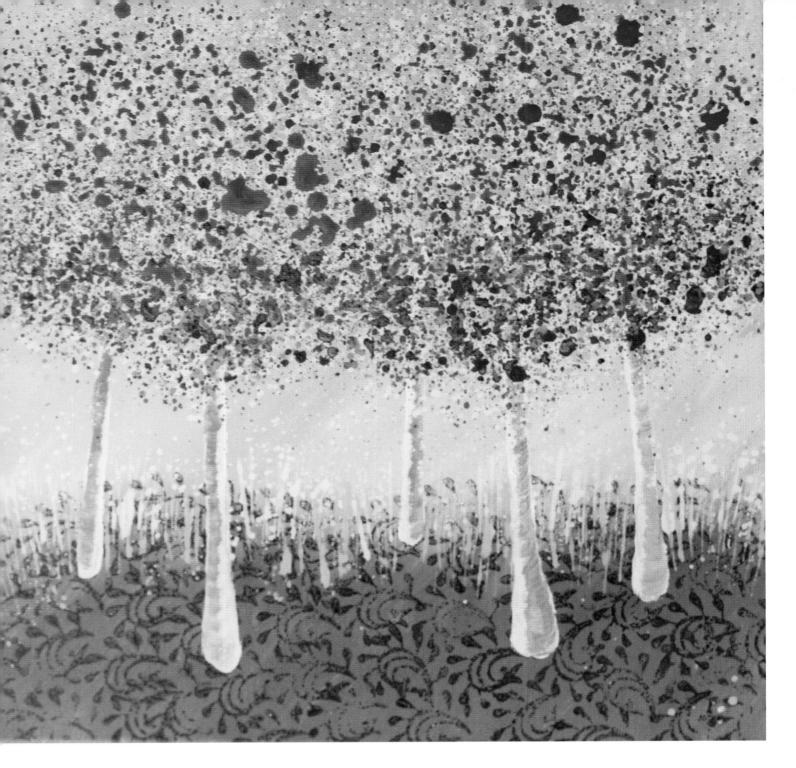

step 3

Continue to build up the foliage by adding layers of spatter. For the lower parts of the trees, use cobalt blue; cobalt blue mixed with white; and a mixture of brilliant blue, cobalt blue, and white. Work your way up the tree with deep magenta, magenta and white, quinacridone magenta, and more white for the treetops. Allow each layer to dry before applying the next.

Add definition to the shadowy edges of the tree trunks by applying cobalt blue mixed with black using a small, flat brush.

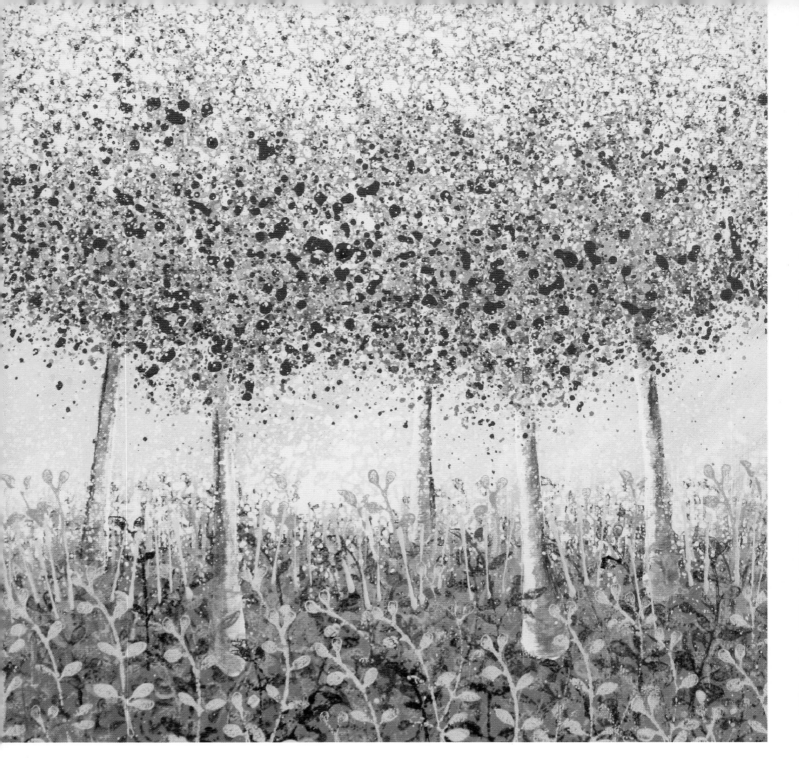

step 4

Now add some plants to the foreground with printing blocks. Begin on the horizon, and gradually work toward the base of your canvas. Print the plants farthest from the viewer in subtle colors, and then gradually include brighter colors as you move to the foreground. I use cobalt blue mixed with white; then cobalt blue, white, and brilliant yellow-green; then brilliant yellow-green, cobalt blue, prism violet with white, and prism violet. I add a few more grasses to the upper foreground using a strip of plastic and a mixture of bright aqua-green, brilliant yellow-green, and white.

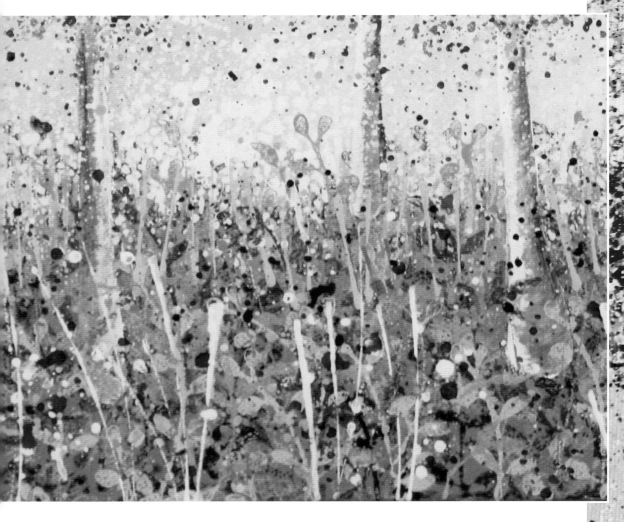

step 5

For the final touches, print some grasses in the middle and near the foreground using deep magenta and white. Add some spatters of deep magenta, white, and a mixture of brilliant blue and white to the foreground. Finish by printing some long, white grasses in the foreground.

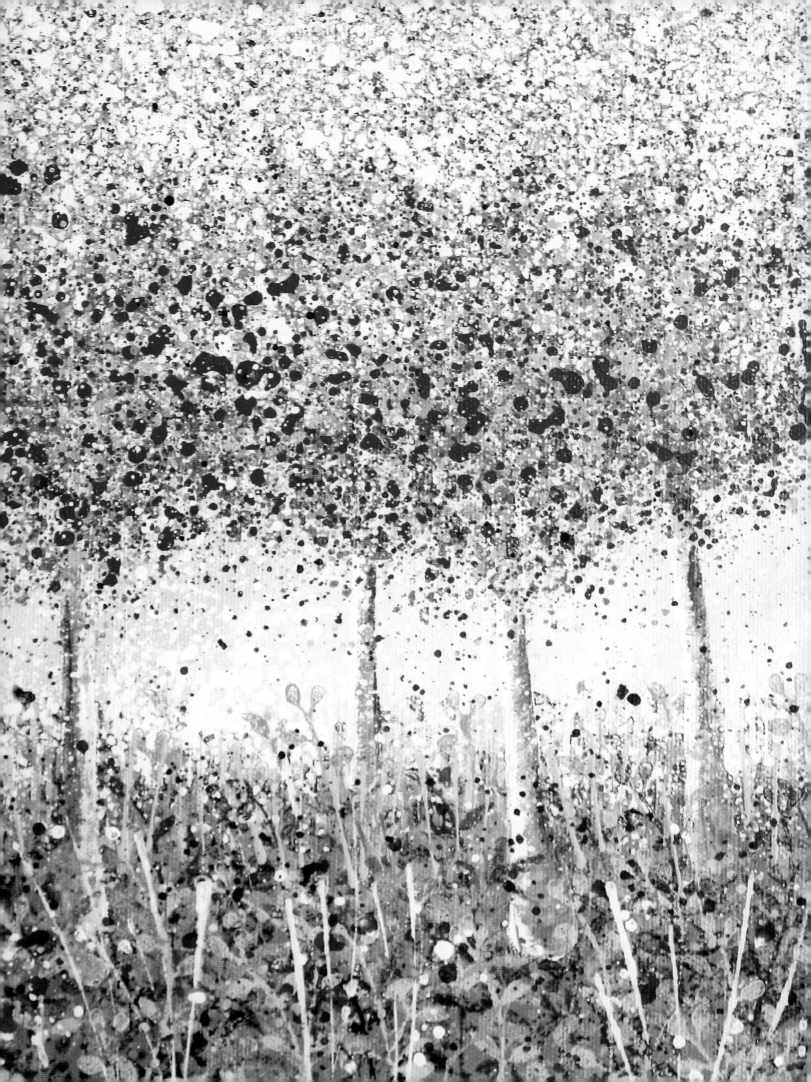

flowers in the forest

FOR THIS PROJECT, I WILL SHOW YOU HOW TO CREATE A MAGICAL FOREST SCENE that features an underpainting technique. Underpainting means that some of the colors and patterns applied to the canvas in the early stages show through to the finished work. This is an interesting and exciting way to create a painting.

step 1

Create a base coat on your canvas by painting diagonal strokes of dioxazine purple and black with a large, flat brush. I use my paint undiluted and straight from the tube, and then just moisten the brush slightly to blend the patches of different colors. Let the painting dry.

With a printing block, print a pattern using a thin mixture of titanium white and Mars black.

step 2

Use a different printing block to add another layer of pattern. I use a paisley design with a shade mixed from Mars black, deep magenta, and white to create a dark pink.

Now create a stencil for the branches of your tree. I use thin card stock and cut out the pieces with a craft knife. Place the branch stencil at the focal point of your picture. Hold the stencil with one hand, and apply white paint with a sponge to your stencil with a gentle but firm dabbing motion. Work upward and outward from this area, moving your branch stencil to create the limbs of each tree. Use white paint first; then, as you move outward, add medium magenta and then deep magenta.

Move the cutouts around on your canvas until you're happy with the composition. Attach them to your canvas with a temporary adhesive material so they stay in place while you paint.

step 3

Continue working outward to the edges of the canvas and just around the tree trunks to give them definition. As you move outward, stencil the branches using prism violet and cobalt blue. If your branches lack definition, add a little white to your paint mix. Remove the stencils from the canvas, and let your painting dry.

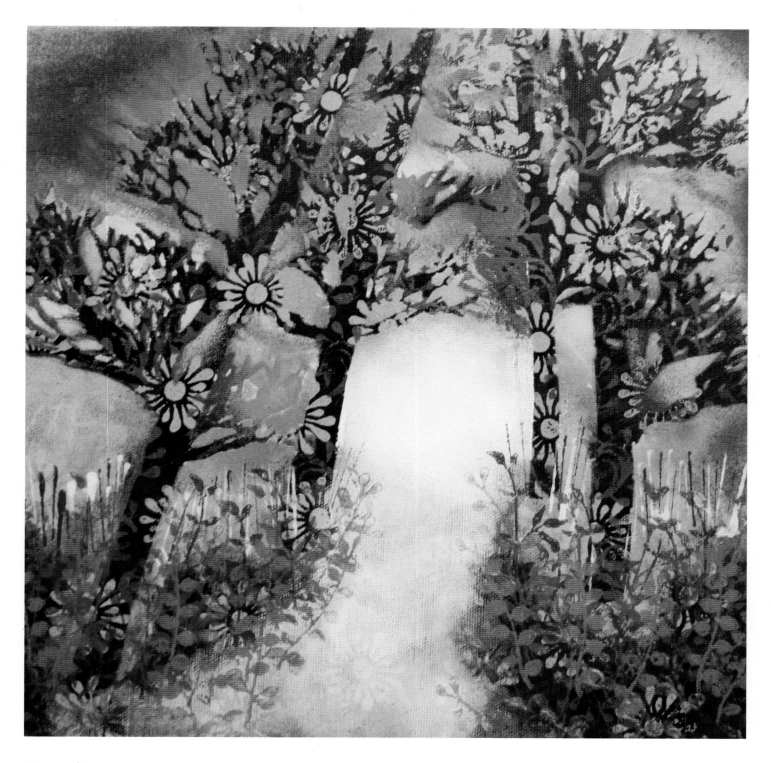

step 4

Now work on the foreground. I use a sponge and my fingertips to apply and blend in some white paint to suggest a path. Use the edge of a strip of plastic to print grasses on the horizon using deep magenta, quinacridone magenta, and white.

Build up the foliage in the foreground with printing blocks in plant designs. Use a sponge to apply the paint to the printing block before each print. I use medium magenta mixed with pyrrole orange, then medium magenta mixed with fluorescent pink, then fluorescent pink, then fluorescent pink mixed with white, and then more dioxazine purple and deep magenta.

step 5

For the finishing touches, I add some shadows to the tree trunks with dioxazine purple and deep magenta, and then I add spatters of white and fluorescent pink.

moonlit

LIVING AND WORKING IN THE COUNTRYSIDE, my paintings are inevitably influenced by the changing seasons. This painting was created in October when the days were still sunny, but the cooler temperatures and dwindling light had changed the colors of the trees and hedges. I'm a musician as well as an artist, and years of driving home late at night from engagements have resulted in many encounters with deer. In this painting, I have tried to suggest the magic of a moonlight meeting with one of these lovely creatures.

step 1

For this painting, I use a square, deep-edged canvas. I begin by applying diagonal strokes with cadmium red, pyrrole orange, and titanium white mixed with cadmium yellow medium using a large, square brush. When the canvas is completely covered, I let it dry.

step 2

This painting will feature an underpainting of patterns that will show through in some areas of the finished piece. With a dampened sponge, apply cobalt blue to a printing block, and print a design all over your canvas. Let the painting dry.

Now mix up some pale gray paint. Use your sponge and a different printing block to print a new design on top of the previous layer.

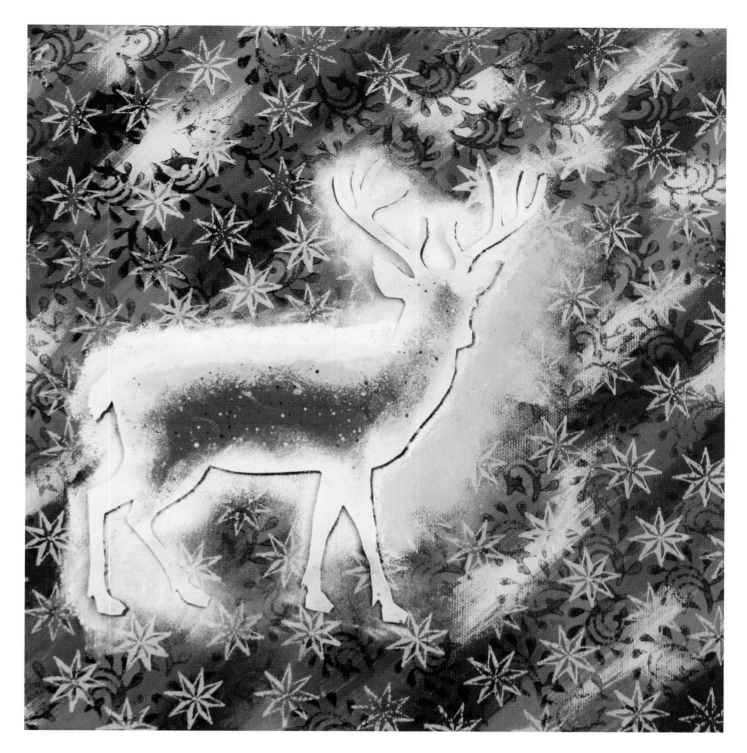

step 3

Create a template by drawing the animal onto a piece of thin card stock and carefully cutting out the shape.

Attach the animal template to your canvas with temporary tacking adhesive. Scrunch up a small sponge between your fingers, sop up some white paint, and carefully sponge over the edges of your template, making sure the template doesn't move. Avoid sponging around the lower legs and feet; here, the underpainting should show through as a base for the autumn foliage.

Mix a little brilliant blue into the white paint, and go around again with your sponge, this time a little farther away from the template. Use your fingers to blend and create a smooth transition.

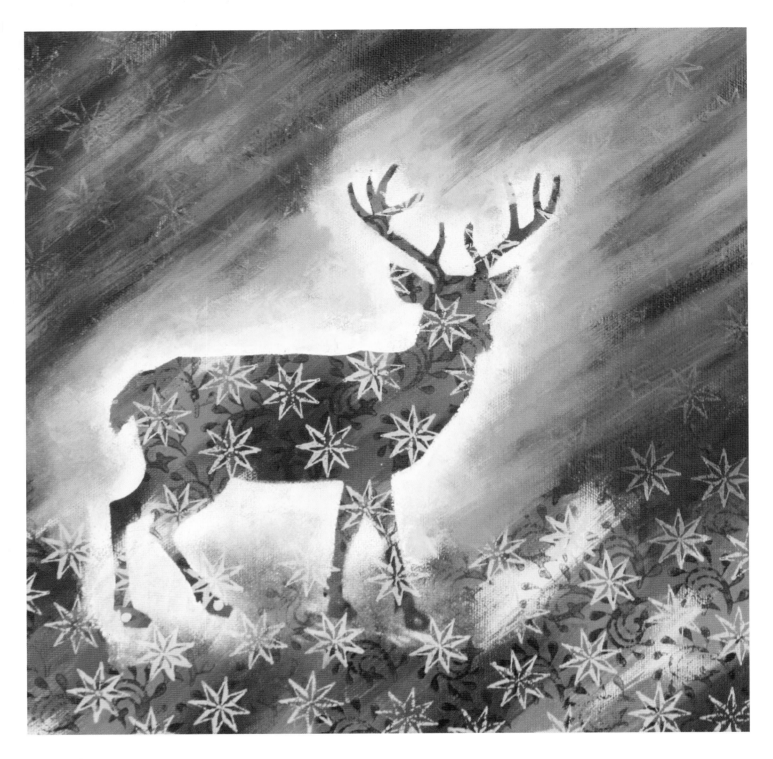

step 4

Apply diagonal strokes of brilliant blue, cobalt blue, phthalo blue, and black to the sky area with a soft-bristled, square-edged brush. I use my paint undiluted, but then add a little water to the brush to blend the edges of the different colors. I work mainly from light to dark, going outward from the animal. I add a few lighter and darker streaks here and there to suggest a night sky with rays of moonlight and clouds.

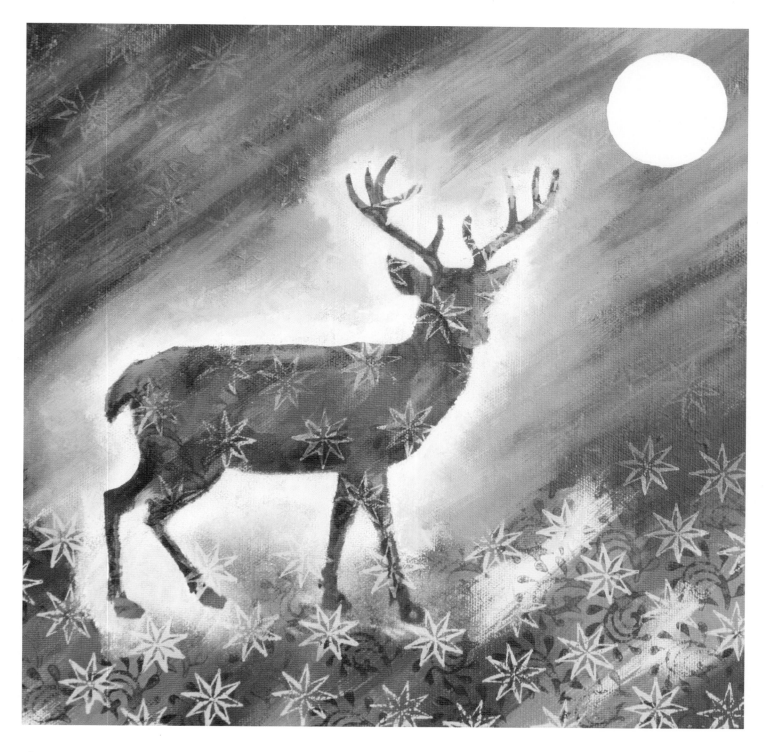

step 5

Now add the moon. I use around a round container to get a perfect circle. Then I paint in the circle using a small, flat brush and undiluted titanium white paint. Let the painting dry.

 With cobalt blue, add shadows to the deer's neck, two legs farthest from the viewer, the back of the haunches, the lower belly, and the ear farthest from the moon. With quinacridone magenta, cadmium red, and quinacridone magenta mixed with white, highlight the head and ear facing the moon, the front of the limbs, the flanks, the back, and the shoulder.

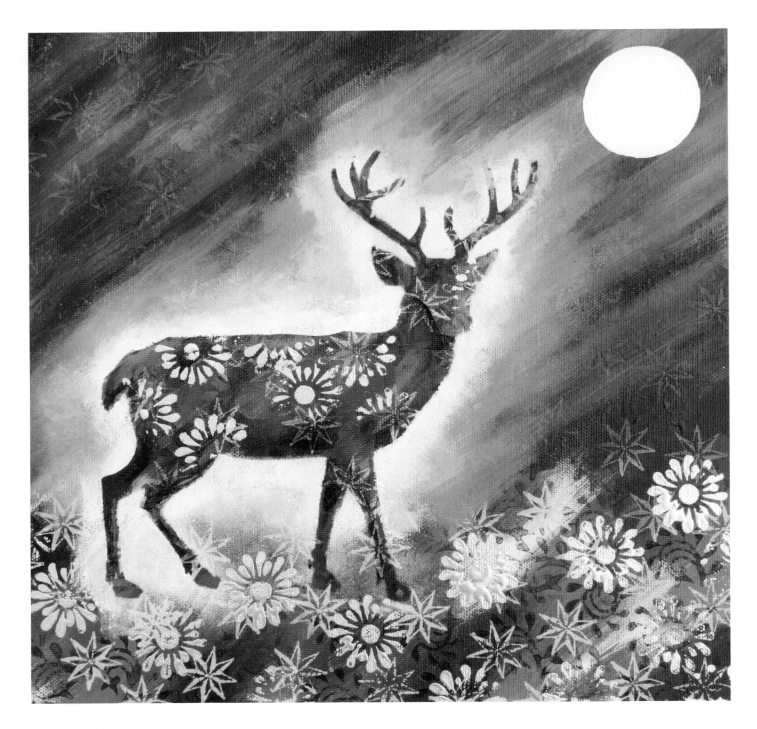

step 6

I like a bit of magic in my nighttime paintings, and I enjoy using metallic paints of all varieties. With a printing block and silver paint, add highlights to the areas where the moonlight would shine on the deer's coat, such as its back, haunches, shoulder, and head. Use a piece of paper to mask areas around the deer to avoid printing onto the background. Add a few silver prints to the foreground to lend a little sparkle to the foliage.

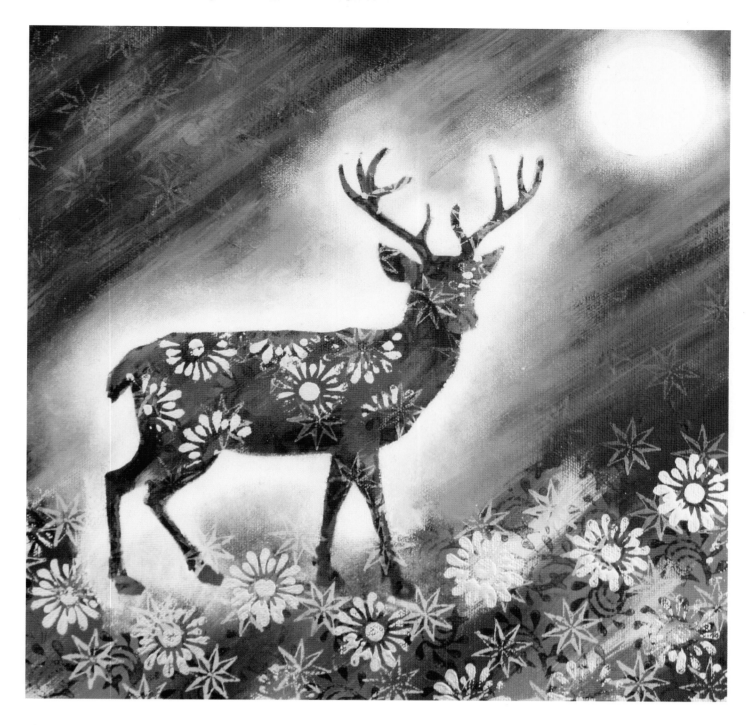

step 7

Scrunch up a sponge with your fingers to create a small, smooth surface for "pouncing" the paint on. With a small amount of white paint, apply strong pressure as you go around the edge of the moon to blur the edges of the shape. Then go around the moon again, but this time decrease the amount of paint and pressure as you blend outward. Place your stencil on the canvas over the deer, and then use the same pouncing technique to finesse the edges of the animal and achieve a smooth blend into the sky.

When adding shadows and highlights, use minimal paint. The aim is to glaze the area, leaving the rich patterns showing through, rather than covering up the underpainting.

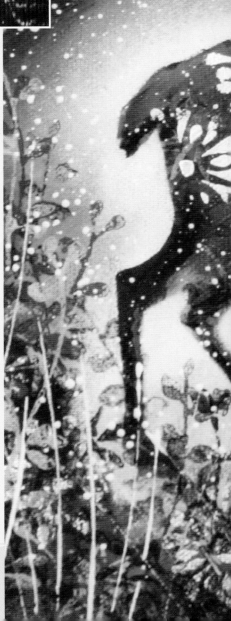

step 8

Now add foliage to the foreground with printing blocks. First use quinacridone magenta; then pyrrole orange; and then a dark brown mixed from pyrrole orange, cobalt blue, and a little black. Use some of this dark brown directly from the sponge to darken the lower edge of the canvas. Continue printing more foliage using cobalt blue mixed with a little white.

For the finishing touches, print some white grass stems using the edge of a strip of plastic or a ruler. Then add some spatters to the foreground with white, cobalt blue, quinacridone magenta mixed with white and cadmium red.

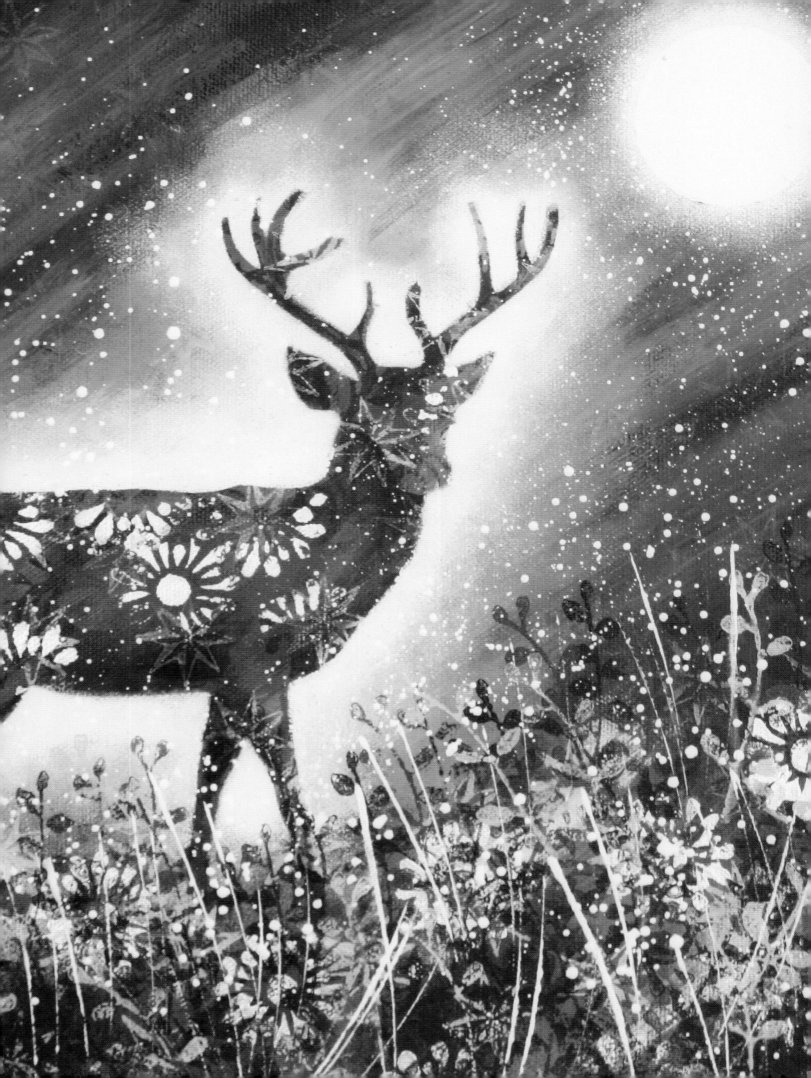

the rain raven

I LOVED CREATING THIS PAINTING ON A RAINY WEEKEND IN NOVEMBER—the bird sprang to life under my paintbrush! The raven casts his eye toward a white, watery sun that emerges from the cloudy, raindrop-laden sky. The black splodges that surround him are reminiscent of ink blots from an ancient book of spells.

This is the most ambitious project yet, and the background requires considerable drying time. Art is not all about instant tricks! Observe photographs of feather patterns, and sketch before painting. The work you put into the project will greatly improve the quality of your finished painting.

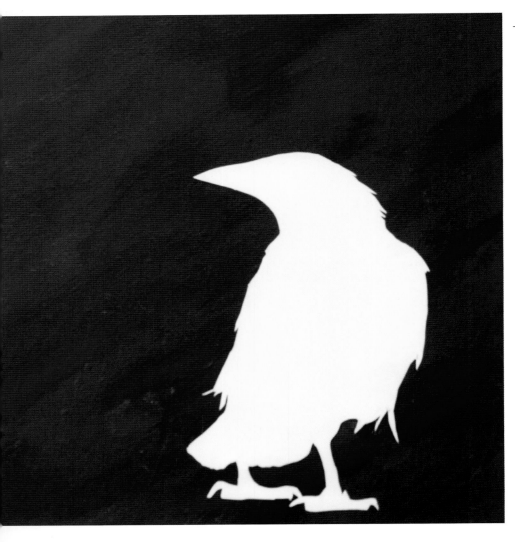

step 1

I start with a square, deep-edge canvas. Then I use a broad, flat brush to apply diagonal strokes of cobalt blue, Mars black, and dioxazine purple. Let this dry.

Now I create a template for the bird on thin card stock. Attach the template to the dry canvas with temporary adhesive tacking material.

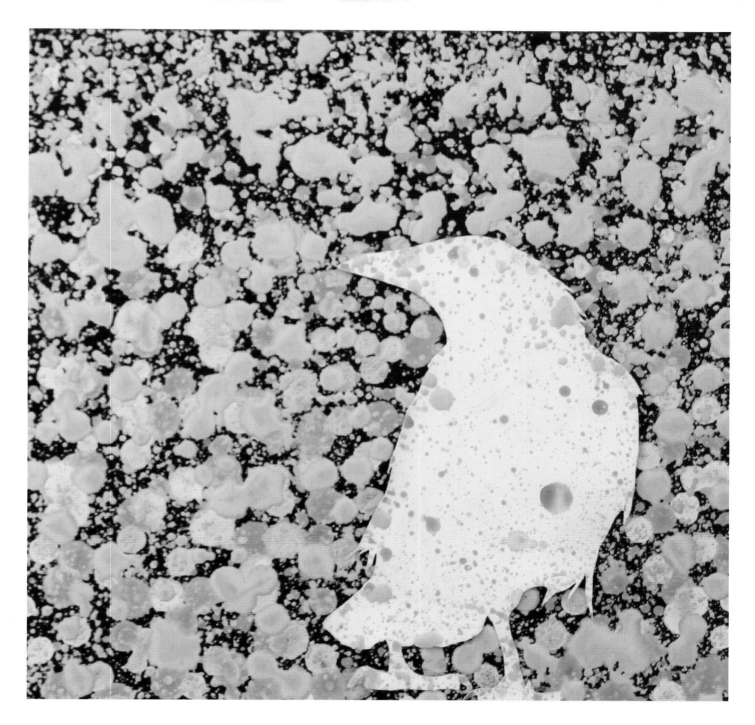

step 2

Create runny paint using a mixture of a little water and brilliant blue, titanium white, and bright aqua-green. With a large brush, spatter the paint onto your canvas. If the paint sticks to your brush, dilute it with a little more water.

While your brush is loaded with paint, direct the spatters to the lower part of the canvas. As the paint on your brush runs out and the spots become smaller, move to the upper part of your canvas.

With a thin mixture of cobalt blue and titanium white, apply drops in the same way. Repeat this step with a mixture of titanium white, black, and phthalo blue. Then repeat with titanium white.

An asymmetrical arrangement is pleasing to the eye.

When spattering and dropping, let the canvas dry between colors to avoid creating muddy mixtures.

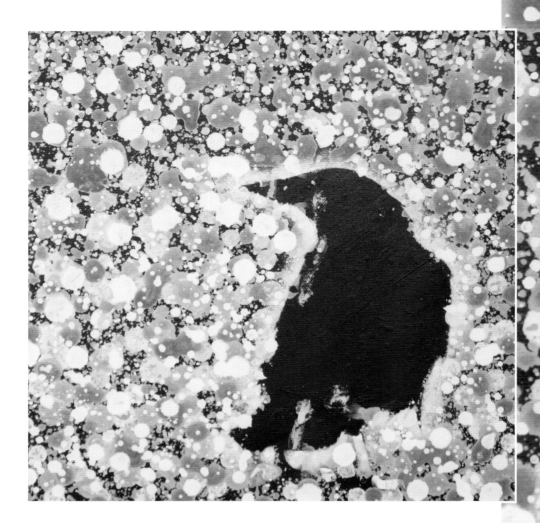

step 3

Define the edges of the bird. Apply a tiny spot of undiluted titanium white to a slightly dampened sponge. "Pounce" the white paint around the edge of your template to mute the spotted background. Remove the template.

Starting with the head, apply the bird's feathers in a series of little "V" shapes using a fine brush, first with a mixture of dioxazine purple and white, and then with a mixture of cobalt blue and white. Define any lighter areas using just a little titanium white on a very fine brush. My brush was almost dry when I completed this stage, which gave my strokes a slightly scratchy look. Use a fine brush to paint a white circle for an eye.

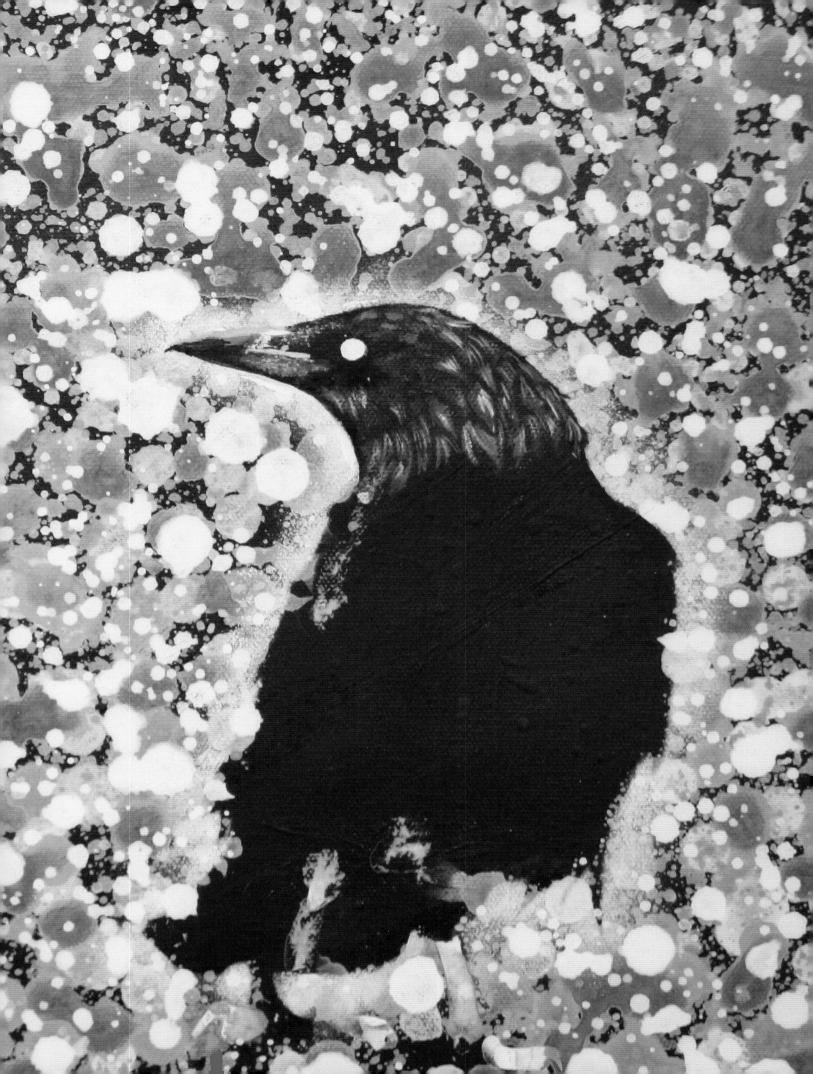

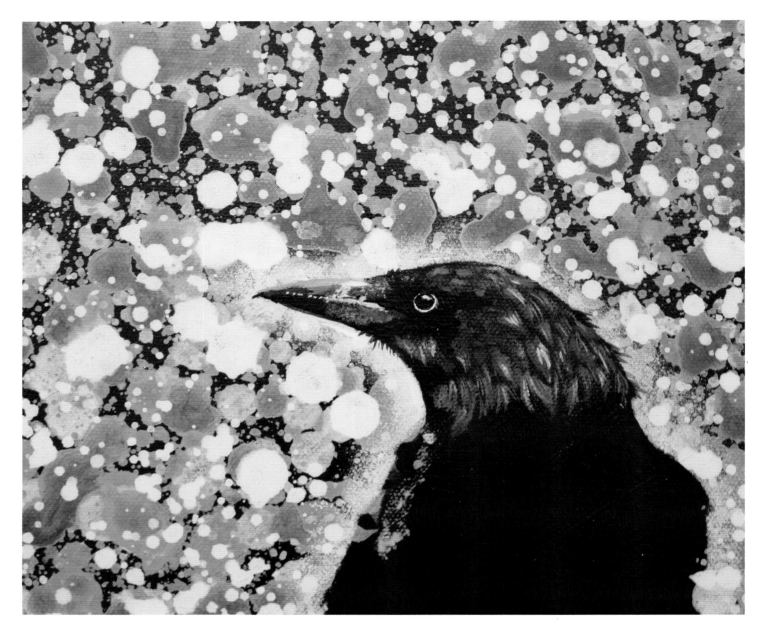

step 4

Complete the bird's eye by painting a Mars black circle over the white circle, leaving a tiny white rim around the edge. Let it dry, and then add a highlight to the eye with titanium white.

Add shiny highlights to the feathers by applying a mixture of brilliant blue and cobalt blue with a very fine brush. With the same brush, add tiny, whiskery feathers around the edge of the bird's head with Mars black.

When painting the bird, your strokes should follow the direction in which the feathers grow.

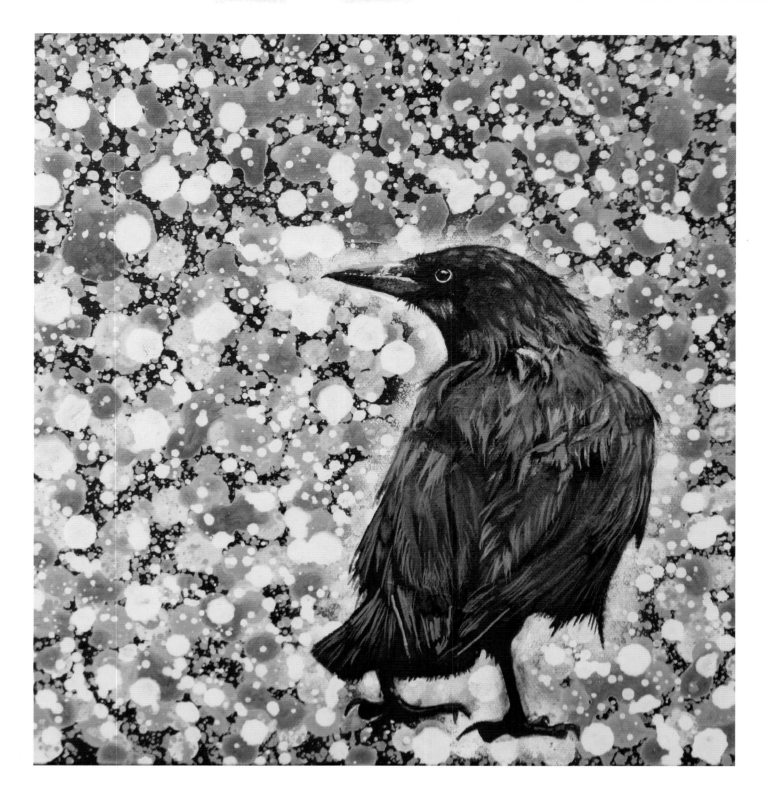

step 5

Using the same colors and techniques that you did for the head feathers, work your way down the bird's shoulders. When all the feathers shapes are in place, add thin strokes of pale gray with a thin brush to create a feathery effect.

Lighten any areas that seem dark with a flat brush and a thin, transparent medium gray. Follow the direction of the feathers with your strokes. To give the raven a magical, iridescent look, use a thin brush to add small strokes of interference blue and interference violet to the lighter areas of the feathers. Add long, fine black strokes to refine the darker areas and make them look like feathers.

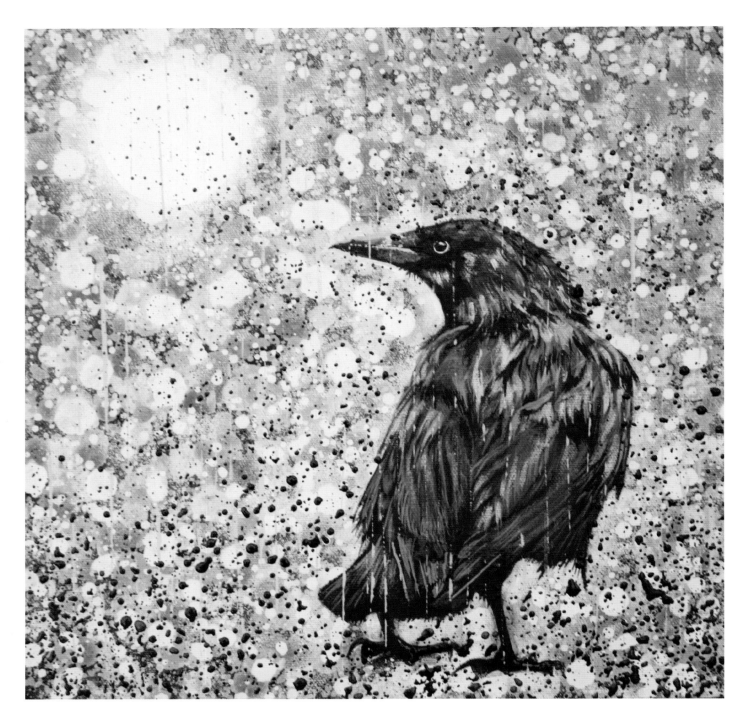

step 6

Draw a sun, and paint it in with titanium white. Roll up a sponge, and "pounce" a tiny amount of undiluted titanium white around the edge of the sun to give it a misty effect. Continue pouncing the whole background gray.

Add some subtle, pale gray drops using a thin mixture of Mars black, cobalt blue, and white. Print very thin, vertical lines over the whole painting using the edge of a strip of plastic. Apply the paint to your plastic strip sparingly using a brush. If the lines are broken as you print them, the effect will be even better.

Place the template back over the bird while you add some spatters of dioxazine purple and black to the foreground in the lower part of the canvas and around the bird.

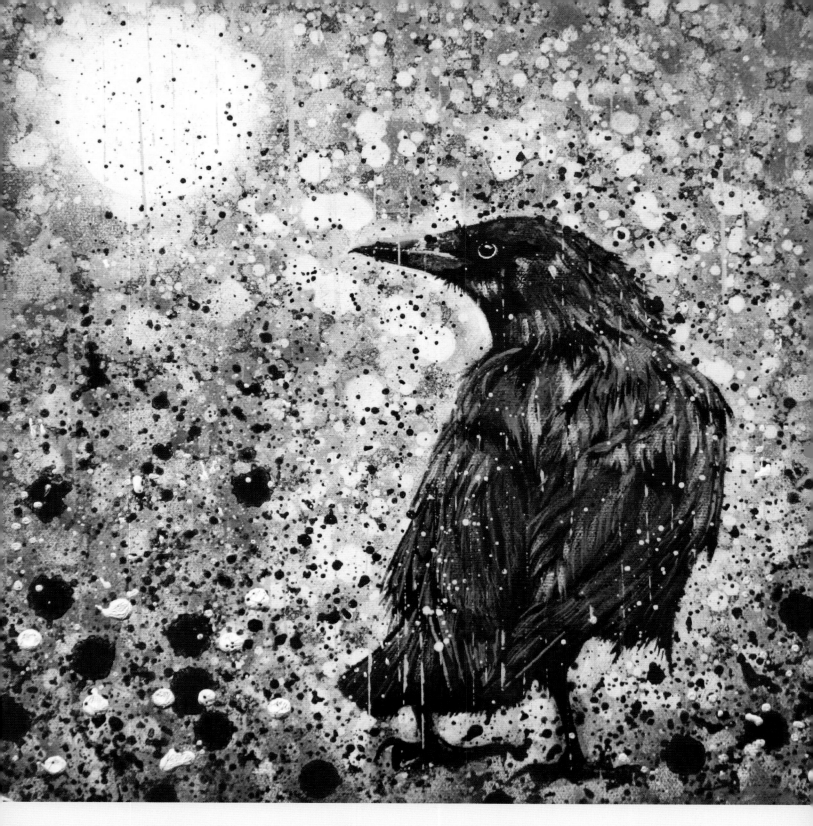

step 7

Now mix up some brilliant blue, Mars black, and titanium white. With a sponge, dab this mixture gently around the edges of the canvas, gradually moving inward to frame the bird. Remove the template, and spatter titanium white with a small brush all over the canvas.

Next spatter silver all over the painting. I put some large spots in the foreground, and then some tiny spatters elsewhere. Finally, with a large brush, drop a few Mars black splodges in the foreground.

yiqi li

YIQI LI WAS BORN AND RAISED IN SICHUAN, CHINA. As a little girl, she enjoyed traditional Chinese brush painting and using all the colors of the spectrum. Twenty years later, she still loves to use color in her oil and acrylic paintings.

Nature and its innate beauty has always been the foundation of Yiqi's paintings, but personal emotion is what gives her art life. With every piece she creates, Yiqi shows how she is feeling and what she wants viewers to feel though texture and colors. She believes that people can have an emotional and spiritual connection with a painting. Yiqi's work evolves daily, and she strives to bring hope and happiness to viewers through her paintings.

Yiqi's paintings can be seen around the globe, from universities to doctor's offices and military bases to the homes of public and private collectors. Her paintings have graced the cover of a faith-inspired book as well as a home-lifestyle magazine.

Yiqi lives in southern Ontario, Canada, with her husband, two children, and Bao the Pomeranian. When she isn't painting, she relaxes with hot yoga and by cooking delicious meals for her family.

Visit her online at www.yiqigallery.com.

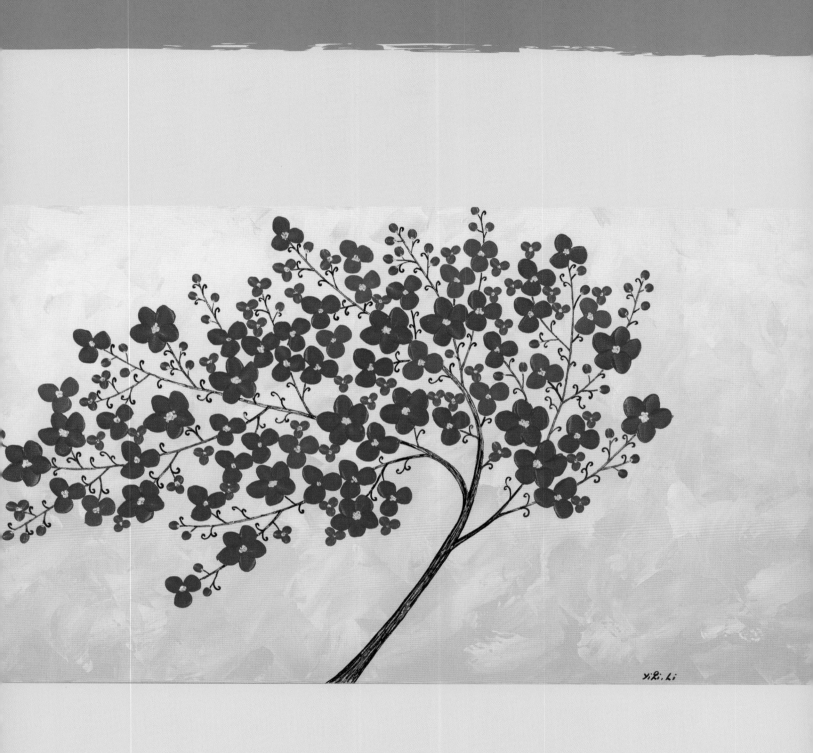

tools & materials

BRUSHES

A flat brush allows you to fill in large areas quickly, but you can also use its edge to paint with great detail.

PALETTE KNIFE

A palette knife is a blunt tool with a flexible steel blade used for mixing or applying paint. It comes in a variety of styles, shapes, and sizes. I use a palette knife to achieve thick texture without much detail. I also use a palette knife to apply mixed media and paint when creating flowers and leaves.

A palette knife enables me to express raw emotions, such as happiness, excitement, calmness, and serenity.

MARKERS

I use oil-based paint markers to draw lines or outline subjects, such as birds and tree branches.

ACRYLIC PAINT

Acrylic paints are easy to work with, and many are nontoxic. Acrylic paint dries fast, so you don't have to wait very long for your layers to dry in order to continue painting.

GEL MEDIUM

I use heavy-body gel medium to increase the paint's consistency. I normally mix the acrylic paint with the medium to add texture, volume, and dimension to my paintings. Gel medium also gives the painting a rich color.

CANVAS

Stretched canvases are nice to paint on because they are taut and easy to maneuver when painting. They're also ready to hang when you're finished!

techniques

I USE THE FOLLOWING THREE TECHNIQUES to create the backgrounds you'll see in my paintings. For a heavy-textured background, I normally mix acrylic paint with heavy-body gel medium to add thickness to the paint. Thick paint makes the palette knife strokes more visible.

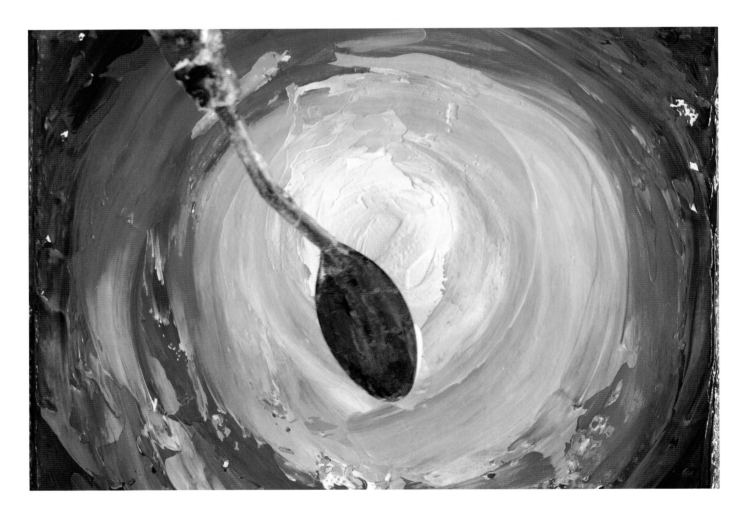

CIRCULAR

The texture in the circular background gives the painting motion and makes it feel alive, as you will see in "Birds on a Wire" on page 104. First I mix heavy-body gel medium with titanium white paint. Then I spread the mixture in the middle of the canvas in a small, circular motion. Then I dab on some cadmium yellow paint, and again I apply the paint using a palette knife in a circular motion, gradually increasing the size of the circle. As I include other colors, I spread them with a circular motion.

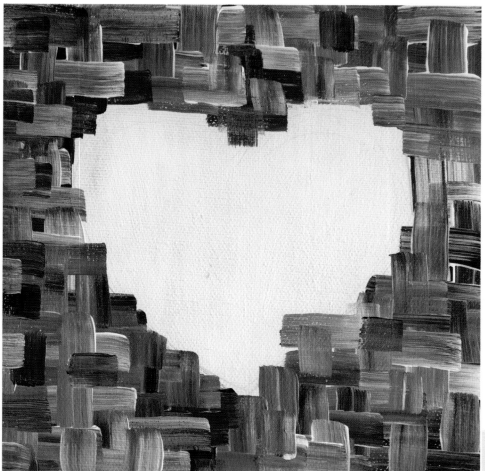

CROSSHATCHING

I use crosshatching for the background in my "Heart-shaped Flowers" painting (page 110). Crosshatching a background is a lot easier when the tip of your brush is flat. Paint one brushstroke, and then paint another stroke on top of the first one perpendicularly. Crosshatching is the quickest and most effective way of varying the background's density and hue.

RANDOM STROKES

With some of my backgrounds, I just randomly apply the paint onto the canvas, like I did in the "Golden Leaf Tree" painting (page 116). The tree branches in the foreground are the focal point, so I make the background flat and less busy. Using this technique, there are a few visible palette knife strokes, but overall, the background is smooth and not at all the center of attention.

birds on a wire

I'VE ALWAYS LOVED MIXING WARM TONES WITH COOL TONES. Together, they create an intriguing, romantic, and mysterious atmosphere. Here I'll demonstrate how to paint a cool-toned background featuring the sky and sun with a simple lovebird silhouette.

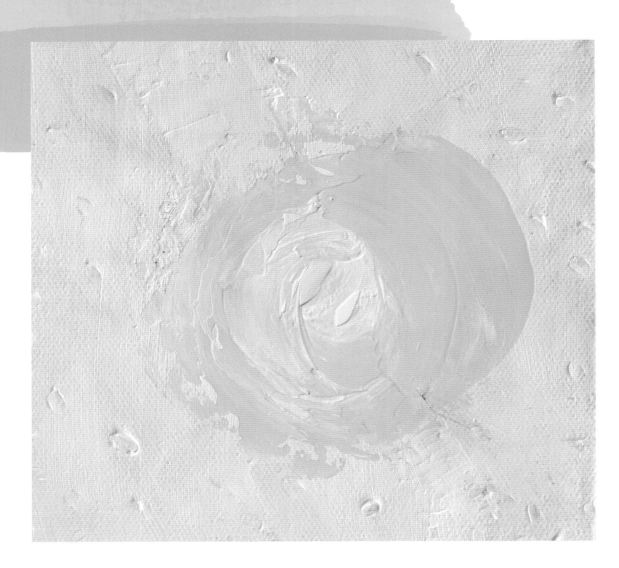

step 1

With a palette knife, cover the canvas with a mixture of gel medium and titanium white. Dab a bit of cadmium yellow in the center of the canvas and paint in a small, circular motion to create a sun. We are aiming for thick textures here.

Gradually increase the size of the circle. It does not have to be perfectly centered or round.

Adding gel to your paints will increase the three-dimensional aspect of your painting.

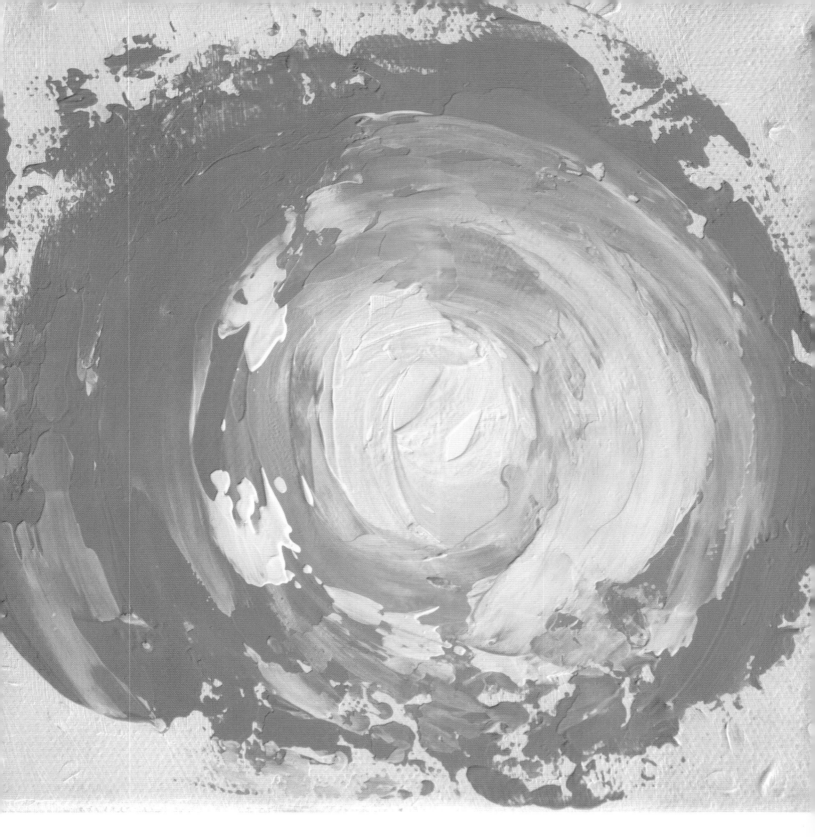

step 2

Paint sky blue light around the sun in a circular motion. We want some of the yellow hue to mix with the blue.
This will help create an ombre effect with transitions of color.

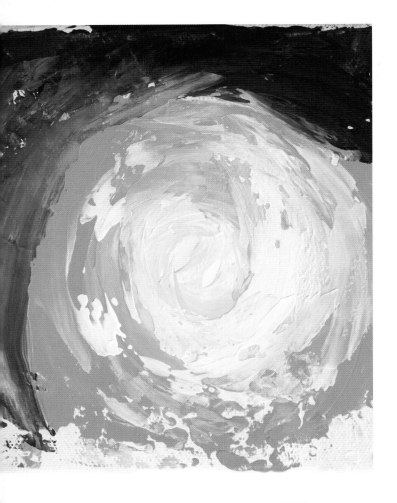

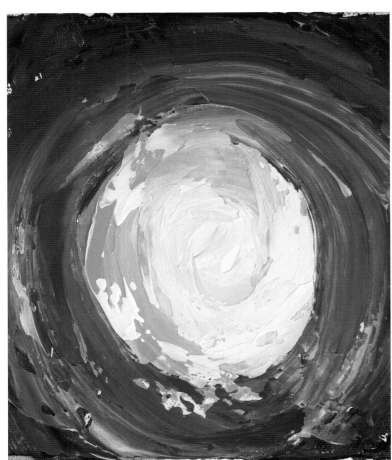

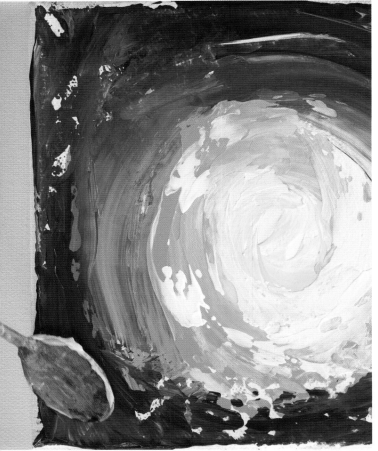

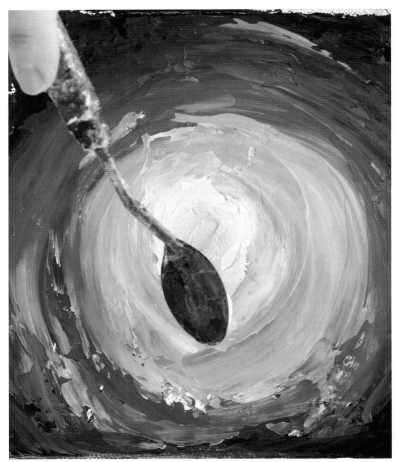

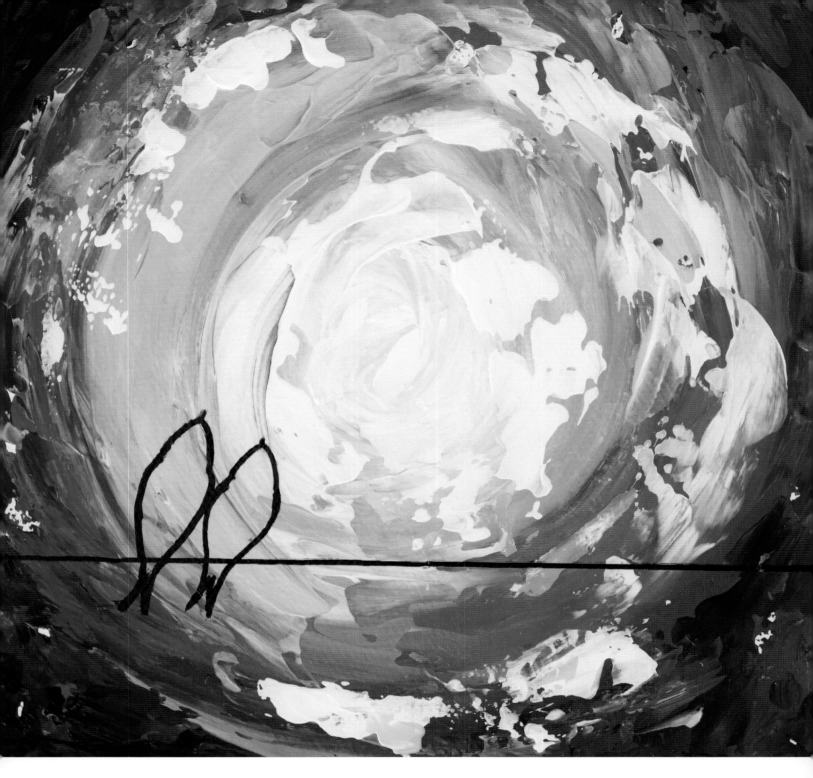

step 3

Paint the outer edges of the canvas with phthalo blue. Avoid mixing the blue too close to the center of the sun; rather, mix toward the outer edges of the sky blue hue. Continue painting in a circular motion. Add some titanium white around the edges of the sun to represent sun rays, which will contrast with the dark blue. Let the canvas dry for one to three hours.

step 4

Now we're ready to draw a wire for our lovebirds to sit on. Using a ruler and a black oil-based marker, draw a straight line across the bottom quarter of the canvas. The line might not be filled in all the way, and that's OK. If you'd rather have a solid line, run the marker over the line until it is filled in to your liking. With the oil-based marker, draw an outline of two little birds. The birds don't have to look like the ones I drew here, but I think this shape is the easiest to start with and very recognizable.

step 5

Fill in the birds with the marker, or use a flat #10 brush and carbon black paint.

Now you have created a romantic, mysterious lovebird painting using a palette knife! Try painting with different colors to set various moods and tones. If you'd like your background to be even more three-dimensional, add more gel medium to your colors. Your choices are endless!

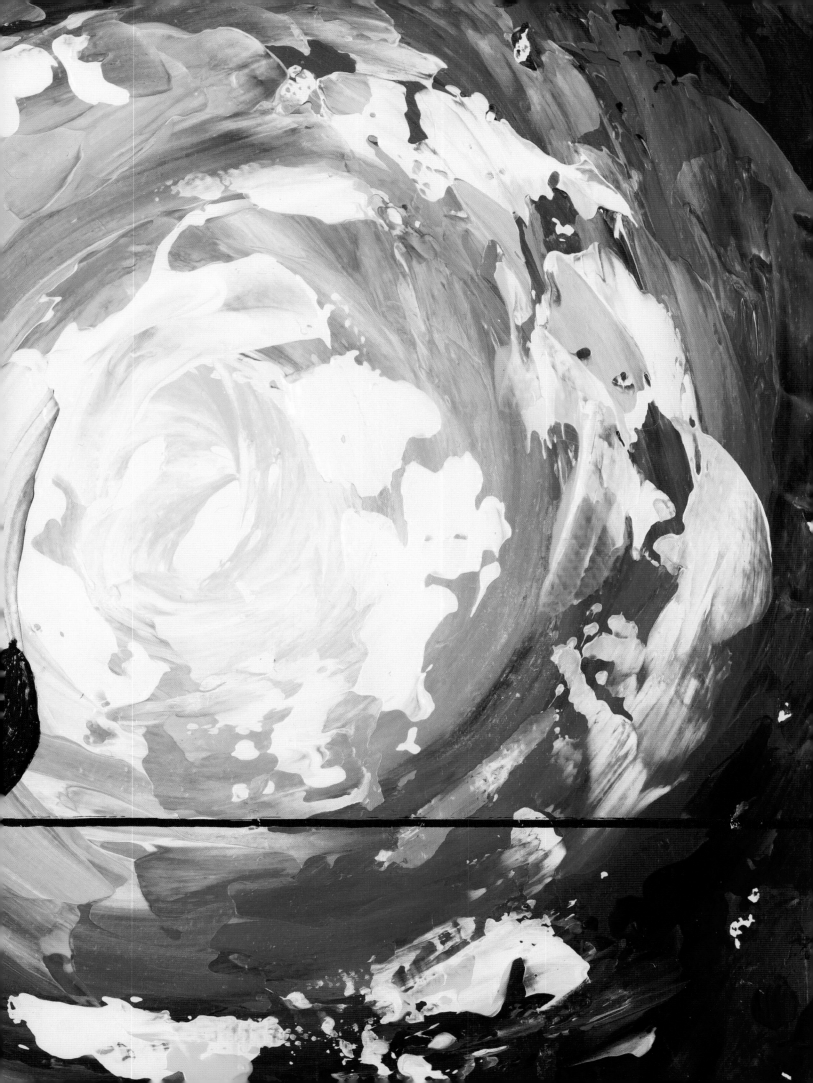

heart-shaped flowers

CONTRASTING COLORS AND THICK TEXTURES can really make your painting pop. With palette knives and gel medium, you can create thick, wavy, juicy textures with the intensity of your choosing. Here, I'll demonstrate how to paint a heart-shaped blossom.

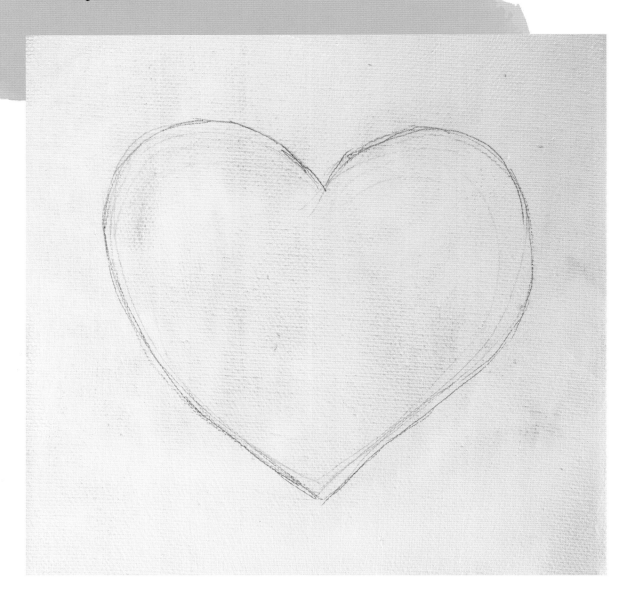

step 1

Using a palette knife, spread titanium white mixed with a bit of gel medium over the surface of the canvas until it's covered. The surface doesn't need to be smooth. Then with a pencil, draw a heart in the center of the canvas.

With a flat brush, mix some gel medium with carbon black paint, and create crosshatches along the outside of the heart.

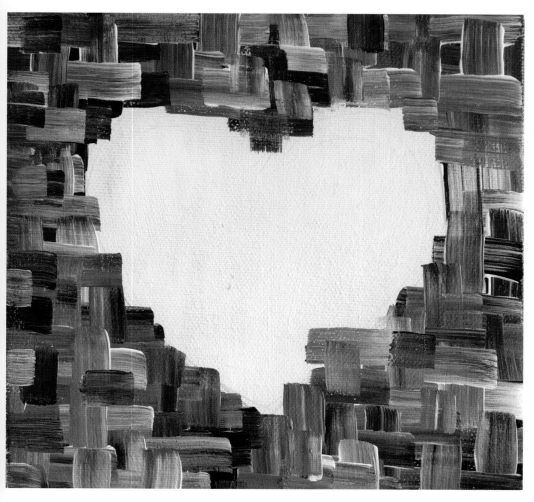

step 3

Continue creating crosshatches on the canvas around the heart. If you see a lot of white in the background, add more carbon black until there is a nice blend of white and black. Let your canvas dry for one to three hours before continuing.

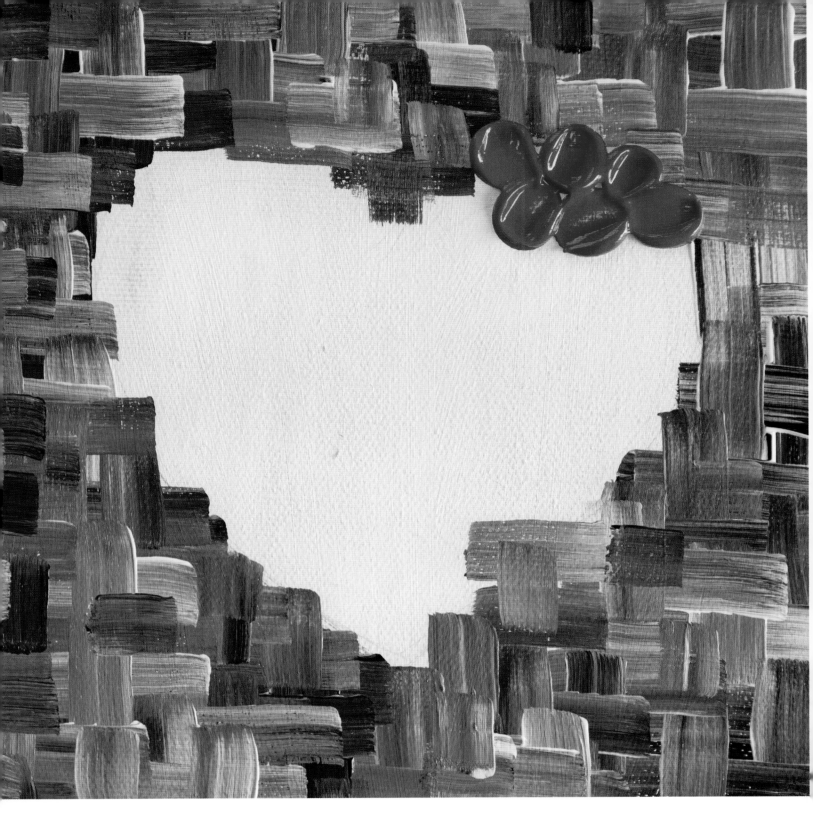

step 4

Now we are ready to add the blossoms, which we'll create with a
mixture of naphthol red and gel medium. With a cylinder-shaped
palette knife, scoop up the paint, and press lightly on the canvas to
leave petals.

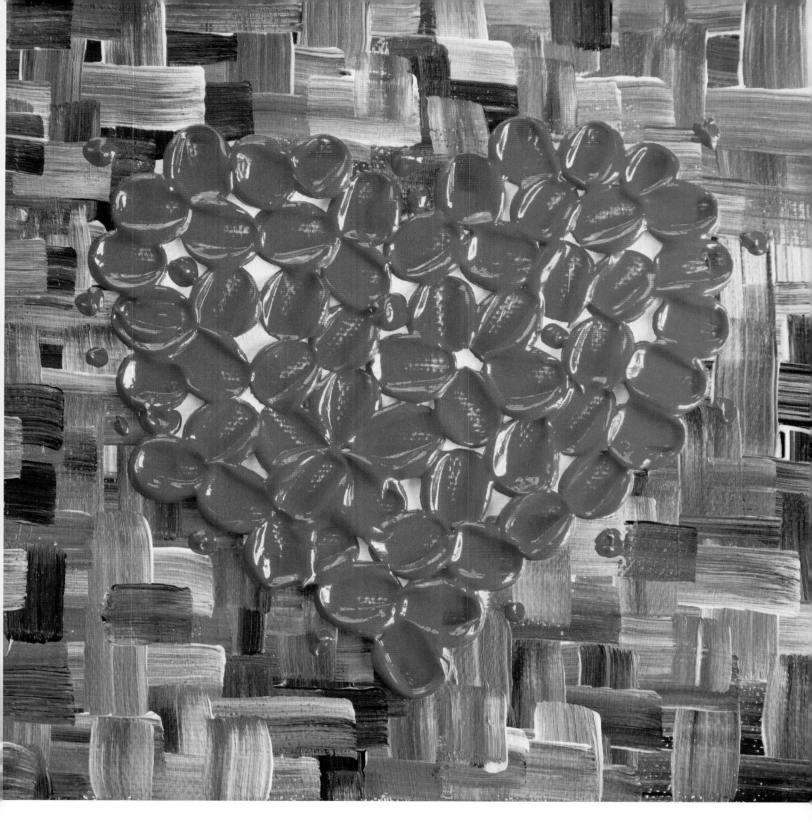

step 5

Continue covering the inside of the heart with petals until the heart is filled.

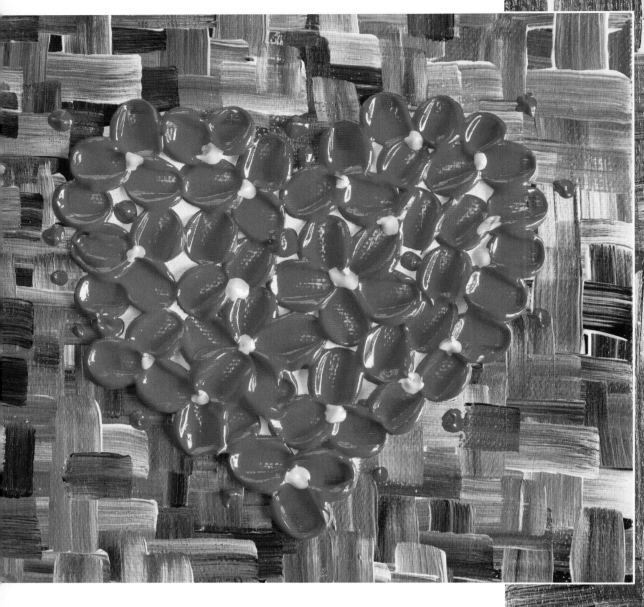

step 6

To make your painting more vibrant, use a round brush and dab a bit of cadmium yellow in the center of each flower.

step 7

Now your painting is complete, but you don't have to stop here. Try adding different colors to the background or to the blossoms. I used only one color for my blossoms to keep things simple, but you can try any number of colors using the same technique. Feel free to try new ideas!

golden leaf tree

WITH PALETTE KNIVES AND MODELING PASTE, you can create thick, irregular textures with unpredictable but interesting results. Here, I demonstrate how to create an abstract tree painting with a palette knife.

step 1

Use a palette knife to mix together modeling paste and titanium white paint. Spread the mixture over the surface of a 12" × 12" stretched canvas until it is covered. The surface will look thick and uneven, but that's the look you are going for. Let the canvas dry completely.

step 2

Sketch tree branches onto the canvas with a permanent black marker. For this painting, I drew two tree branches on two diagonal corners.

step 3

Mix metallic gold paint with heavy-body gel medium. With a palette knife, apply the tree's leaves onto the canvas.

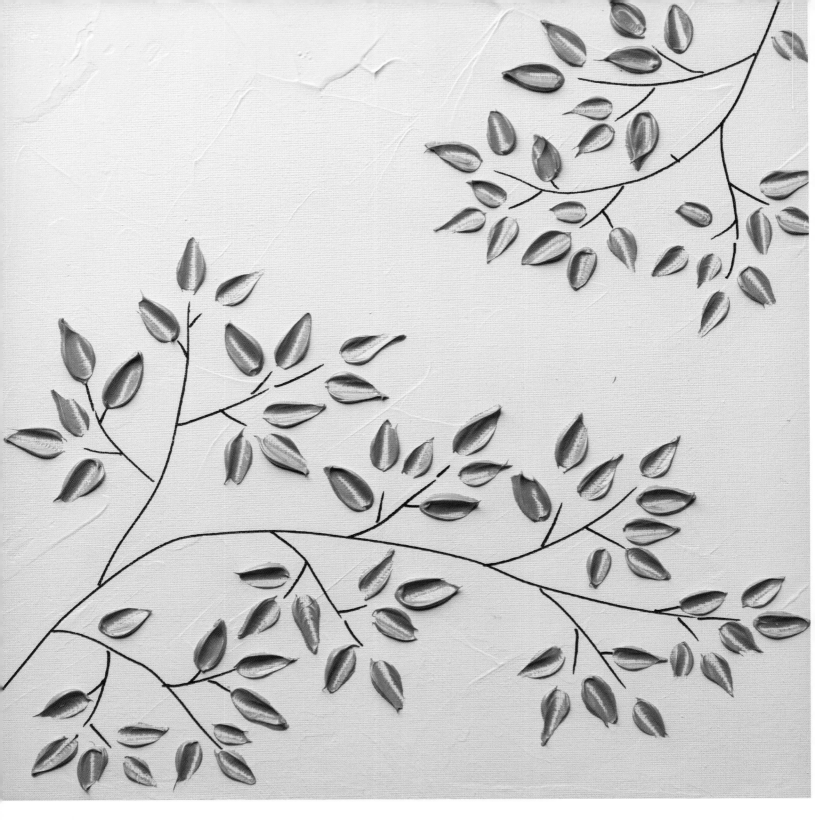

step 4

Add gold leaves to the rest of the branches, and then let the canvas
dry completely.

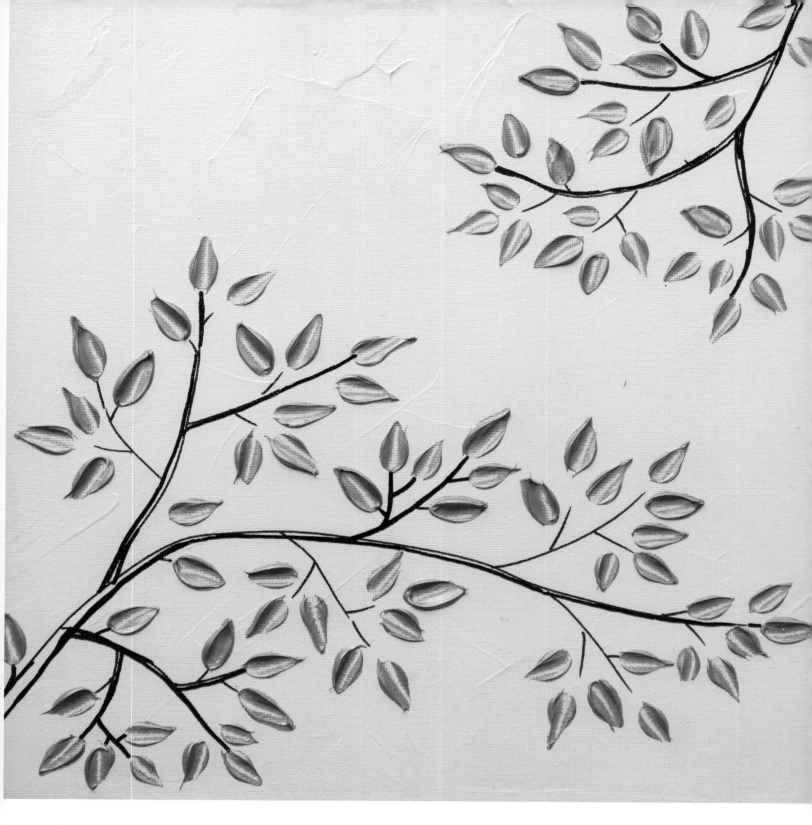

step 5

With a black permanent marker, outline the shape of the tree branches.
Then add details to the branches with the same marker.

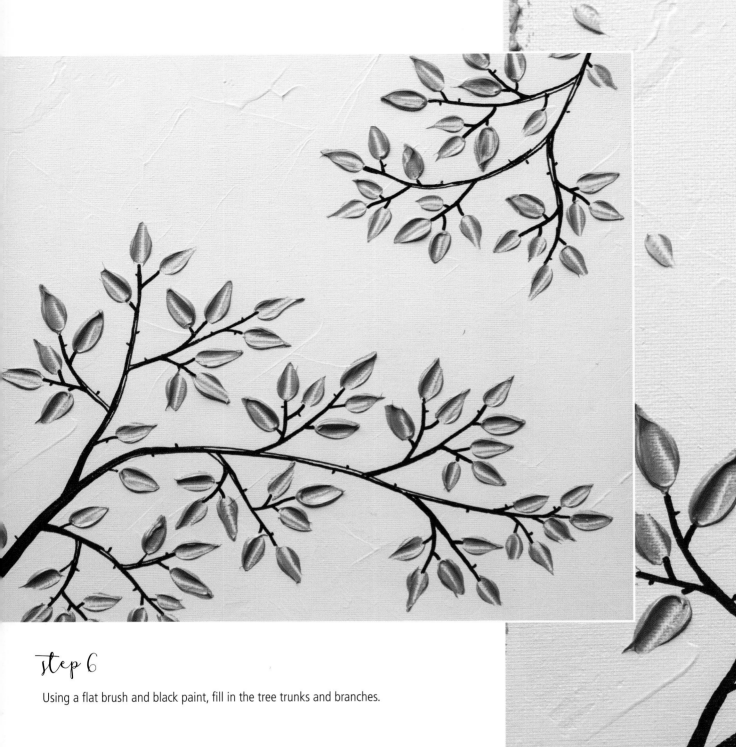

step 6

Using a flat brush and black paint, fill in the tree trunks and branches.

step 7

For the final step, randomly add some falling golden leaves to give the painting more life and movement. Then with a palette knife, scrape some golden paint around the edges of the canvas as a decorative final touch.

rainbow flowers

RAINBOWS SYMBOLIZE PEACE AND SERENITY. This abstract flower painting is very colorful and beautiful, but keep in mind that it will require more paint colors than the previous projects.

step 1

Using a palette knife, lay out the colors on the top third of the canvas in the following order: crimson red, naphthol red medium, orange, deep yellow, primary yellow, titanium white, olive green light, olive green deep, iridescent blue green, phthalo blue, ultramarine violet, and deep violet.

step 2

Spray clean water on the colors with a spray bottle.

step 3

Carefully tilt the canvas forward and backward so the paint flows up and down along with the water.

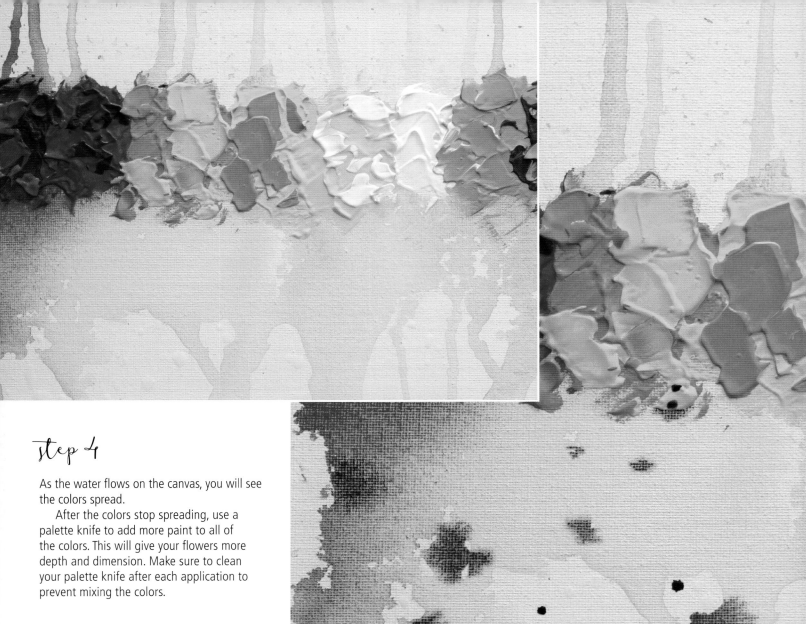

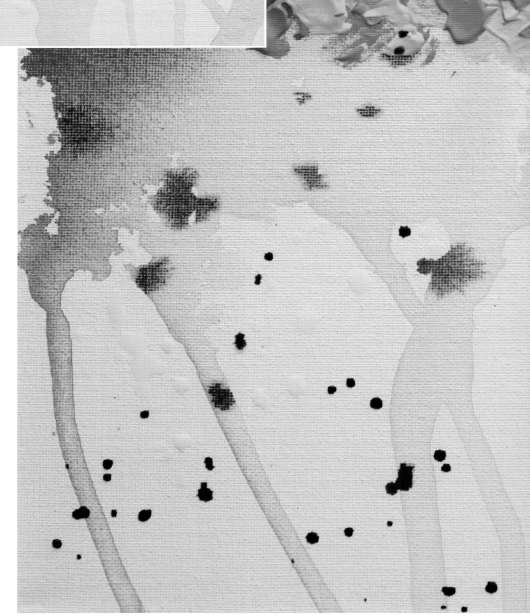

step 4

As the water flows on the canvas, you will see the colors spread.

After the colors stop spreading, use a palette knife to add more paint to all of the colors. This will give your flowers more depth and dimension. Make sure to clean your palette knife after each application to prevent mixing the colors.

step 5

Now overlay different colors on top of the base colors. With a palette knife, gently press some naphthol red medium onto the crimson red. Clean the palette knife, pick up some crimson red paint, and gently press it on top of the naphthol red medium area. When you apply the layers, let some of the original color show—don't cover them completely. Use the same technique to add complementary colors to the rest of the flowers, such as deep yellow on orange and orange on deep yellow.

Now thin a little blue paint with water. With a flat brush, randomly spatter the paint onto the bottom half of the canvas.

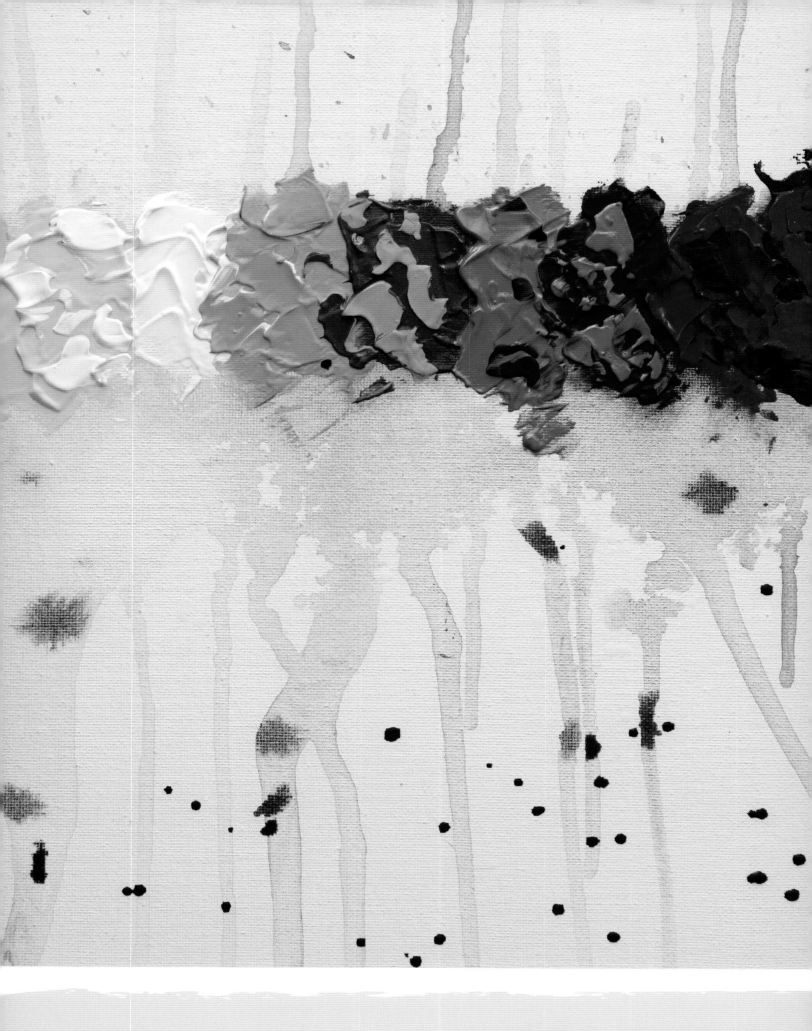

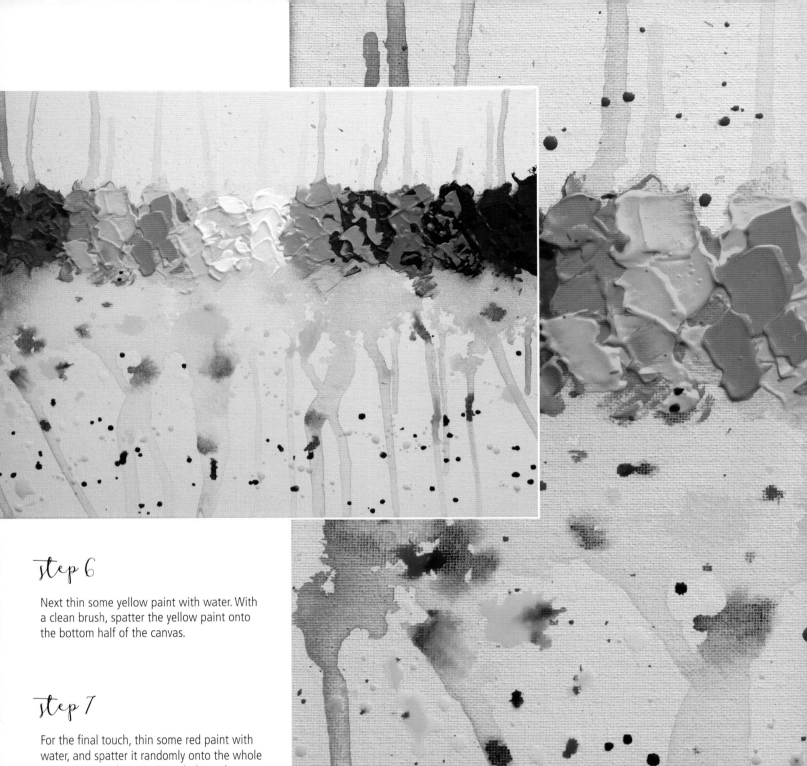

step 6

Next thin some yellow paint with water. With a clean brush, spatter the yellow paint onto the bottom half of the canvas.

step 7

For the final touch, thin some red paint with water, and spatter it randomly onto the whole canvas to give the painting a balanced, cohesive look.

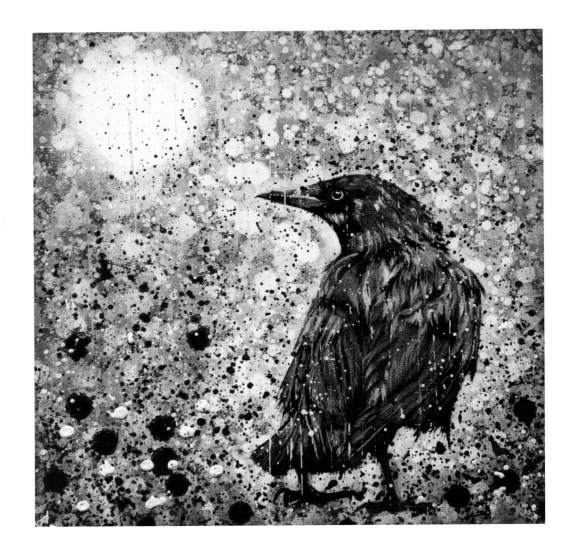

closing words

By now, you've experimented with a wide variety of oil and acrylic painting techniques, from spattering and palette-knife painting to using just your fingertips to create vibrant, textured works of art. Use the projects featured in this book, or combine different techniques to create your own original, expressive artwork. The possibilities are endless!